# RYE AND AROUND
## From Old Photographs

ALAN DICKINSON

AMBERLEY

Haymaking on Rye Hill, probably in the 1890s, showing the rural surroundings of the town before Edwardian development on the northern outskirts. The workforce shown here includes a woman dressed in the contemporary working-class costume – a boater, a long skirt and a big apron. The photograph recalls the description given by Rye historian Jeake in 1678: 'This ancient town is compact as a little City stored with Buildings, The Town is of beautiful Prospect to look upon any way' (courtesy of Rye Museum).

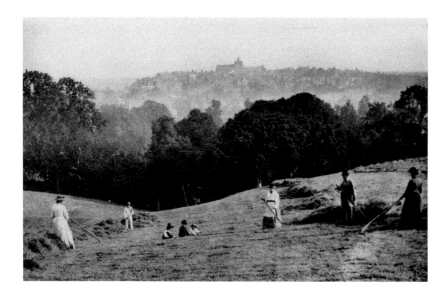

First published 2016

Amberley Publishing
The Hill, Stroud
Gloucestershire, GL5 4EP

www.amberley-books.com

Adapted from *Around Rye in Old Photgraphs* (1989), by the same author.

British Library Cataloguing in Publication Data.

A catalogue record for this book is available from the British Library.

ISBN 978 1 4456 5899 5 (print)
ISBN 978 1 4456 5900 8 (ebook)

Typesetting and Origination by Amberley Publishing.
Printed in the UK.

# Contents

# Introduction

The small town of Rye is a well-known tourist centre, combining a fine heritage of historic buildings with a unique hilltop setting. As one of the Confederation of Cinque Ports, along with its sister town of Winchelsea, Rye at one time provided ships for the king in return for privileges. In 1377 it suffered a disastrous raid by the French and much of the town rebuilt following this period still survives today. Popular with artists and writers, it is frequently crowded with visitors of many nationalities.

In the Victorian period Rye was a flourishing port having both seagoing sailing trade and river barges transporting goods inland. The fishing fleet boasted vessels of many sizes and seasonal netting was carried out on the shore. Shipbuilding was an important local industry employing a large workforce, and at one time there were also three breweries in the town, an iron foundry and an engineering works.

As a market town Rye was the commercial centre for a wide rural hinterland and overlapped with other market centres in Kent and Sussex. In 1898 the town was served by twenty-five carriers travelling as far as Hastings, Tenterden, Woodchurch and New Romney with corn markets held fortnightly. There were also a multitude of shops, inns, trades and professions, many providing services to an area much wider than the town itself.

In addition to possessing its own Borough Corporation and Law Courts, the town served as an administrative centre for a defined rural area beyond its boundaries (see map on p. 128). The Poor Law Union, comprising twelve parishes, was later utilised as the area governed by the Rye Rural District Council and as a County Court and Magistrates Division. It is this administrative area that was chosen as the boundary for the photographs in a previous book, *Around Rye in Old Photographs,* which was compiled by the author in 1989. Much of the photographic material in that book is reproduced and reissued in this volume, which focuses more on the historic town than on the rural and costal hinterland but includes photographs drawn from these areas in the sections on the port and farming and other topic areas.

The town of Rye is set in a distinctive island crowned by the parish church. It is surrounded by both the flat levels forming part of the Romney Marsh and

more widely by three river valleys and villages on the wooded hills of the High Weald. The population of the Rural District Council area in 1901 was 11,078 including 3,900 in the Borough of Rye.

Within the rural area the photographs reveal a slower more ordered way of life. The squire was the dominant economic and social figure in many parishes, when a number of estates being built up or expanded in the nineteenth century. Few farms were owner occupied and many were held on annual leases with little security. Mixed farming predominated, with hops, wheat and grazing being prominent. Villages were more self-sufficient than today; the contemporary directories list many vanished shops and trades in addition to those supporting agriculture. In the days before modern benefit provisions the workhouse loomed large as the ultimate destination of those who fell on hard times. Some parishioners belonged to village slate clubs which provided an annual treat and a measure of security.

In the twentieth century there was a shift away from farming and industry towards tourism. As early as 1902 land at Camber was sold with 'sites suitable for bungalows', and between the wars, plot-land 'development proliferated on or near the sand dunes at Camber and the shingle ridges at Winchelsea Beach'. More affluent visitors included golfers and well-known authors and artists, boosting the boarding house and hotel trades. A growing band of part- and full-time residents populated new suburbs on Rye Hill and restored cottages in the town. While shops increasingly catered for tourists the town became more conscious of its past; a committee for the preservation of ancient buildings of Rye was formed in 1895 and the museum, first projected in 1889, was founded in 1928. Rural estates meanwhile, hit by falling rents and taxation, were increasingly broken up and sold after 1918, largely to tenant farmers and sometimes as select building plots. Improved road communications including motor-bus services from the 1920s were coupled with a decline in village shops and services.

The author acknowledges help and advice from many sources in the preparation of the original book in 1989 including Rye Museum for permission to reproduce so extensively from the museum's collections, to Peter J. Greenhalf ARPS for the photographic work and Clifford Bloomfield, Peter Ewart, Gwen Jones, Frank Palmer, Steve Peak, Bryon Purdey for information on specialist topics. I am grateful to my partner Lesley Voice for her assistance and patience in the preparation of the current revised book. Published sources include old trade directories and local newspapers. The following photographs are reproduced from the John E. Ray glass negative collection in Hastings Library. This is the property of East Sussex County Council and may not be reproduced in any form without the prior consent of the council: p. 21, p. 23 (upper), p. 33 (upper), p. 95 (lower). Owners who have kindly allowed reproduction of their photographs are acknowledged in brackets at the end of each caption apart from the material from the author's collection.

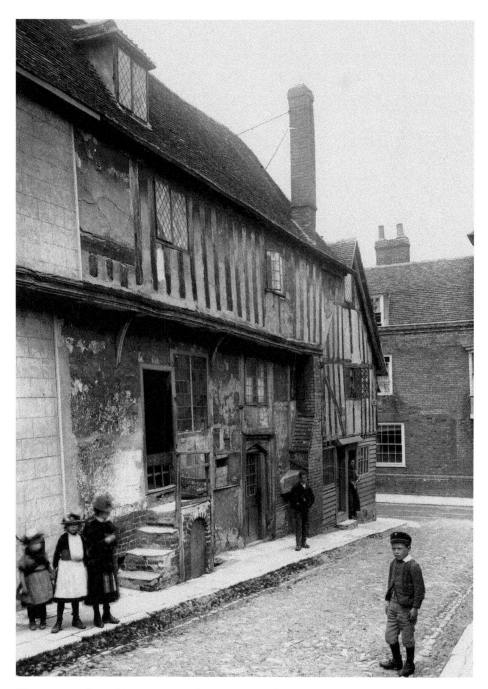

West Street in the early 1890s – one of a fine collection of photographs by the amateur Hastings photographer George Woods. The buildings were fifteenth- and sixteenth-century houses which had been converted into cottages and were demolished in 1895. The lack of any attempt at modernisation indicates a low status. In contrast, the building in the background was the residence of the Misses Pix and bears the scars of its conversion from a shop, (courtesy of Hastings Museum).

# Section 1

# The Town

The following photographs illustrate the streets and buildings of an ancient Cinque Port town adapted to the needs of a bustling market centre of the nineteenth and twentieth centuries. Most of the medieval defensive monuments and public buildings survive within a modified grid of cobbled streets. The town was however largely rebuilt during its time of greatest prosperity, in the early sixteenth century. Many of these buildings, largely refaced during the Georgian period, have survived despite wartime bombing. The nineteenth century saw many houses subdivided with additional cottages added on behind them. Ownership was fragmented at this time, although there was a tendency for investment by leading businessmen.

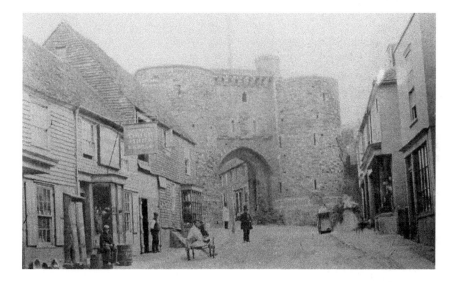

**The Landgate, c. 1870**
The fourteenth-century gate survived the sale and demolition of monuments carried out by the eighteenth-century corporation. In the sixteenth century the street had developed as a suburb outside the defensive ditch and walls of the town. The presence of the Towner Inn is recorded as from 1846 to 1901; Thomas Jordan had succeeded William Henry Mills as landlord by 1874. The picture post-dates 1863 when the clock was added to the Landgate, (courtesy of Frank Palmer).

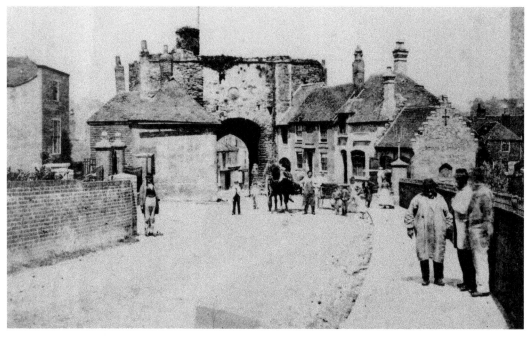

**The Landgate from Hilders Cliff,** *c.* **1880**
This road near the cliff edge was improved in the 1860s by the Corporation – it is its railings which can be seen on the right. Tower Forge adjoining the gate was partly rebuilt in 1878 – the figure in the long apron standing in the street was probably the blacksmith, Silas Winton. The rotund character in a long smock was probably a farm carter or shepherd, (courtesy of Rye Museum).

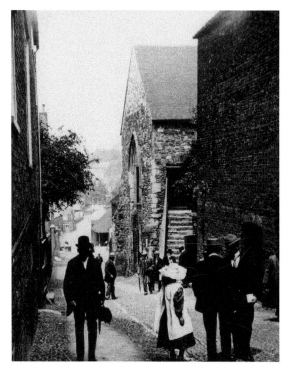

The Monastery from Conduit Hill, 15 June 1901
The building was the chapel of the Augustinian friary, which was put to many secular uses following the Dissolution. In 1901 it was a Salvation Army barracks and an artist's studio. One of Rye's cobbled streets, Conduit Hill, had been the main route of the town's piped water supply from at least the sixteenth century, and the nineteenth-century pump house, largely rebuilt in the 1970s, may be seen at the foot of the hill, (courtesy of Rye Museum).

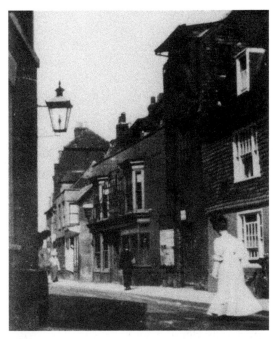

**A Visitor to Rye,** *c.* **1907**
Miss Clements of London, recorded
by the amateur photographer
J. H. Chatterton. The double-fronted
building in the centre was the Oak Inn,
which had a short life in the 1900s
before becoming tearooms. Flanking
it in 1859 were Broad's candle factory
on the left and the factory's warehouse
on the right. By 1899 the factory was
also functioning as a grocer's shop run
by the former manager George Pellett,
(courtesy of Beryl Hutchings).

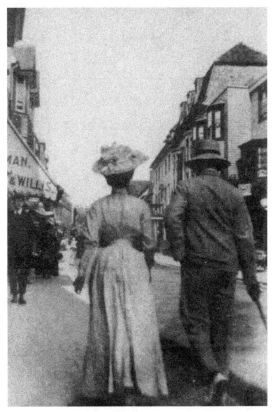

**An Informal Scene in the High
Street, 1 June 1907**
The commercial centre of the town
has always been busy with pedestrians.
Freeman, Hardy & Willis was one
of the earliest multiple retailers to be
established in the town, being first
listed in 1887. The firm moved from
No. 22 to No. 23 High Street shortly
before the date of this photograph,
(courtesy of Beryl Hutchings).

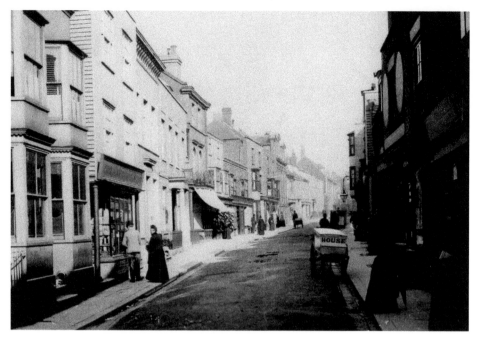

**The High Street Looking East, Late Nineteenth Century**
The delivery cart belonged to baker Charles House, who was listed in the directories printed between 1885 and 1899 as trading at No. 89 (courtesy of Rye Museum).

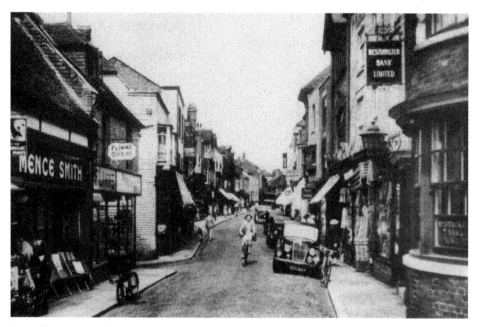

**The High Street with Motor Traffic, 1937**
The shopfronts have changed over the years but the buildings remain largely as they would have been in the eighteenth and nineteenth centuries. The three well-known multiple retailers, Mence Smith (ironmongers), Flinns, and Boots, were all established in Rye in the 1930s.

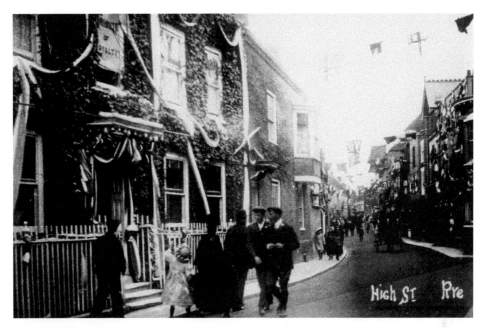

**The High Street, Decorated for the Coronation of George V, 1911**
The building on the left was Bank House, home of an eighteenth-century solicitor and town clerk, Jeremiah Curteis. The house was demolished to make way for a branch of Woolworths in the 1930s, (courtesy of Frank Palmer).

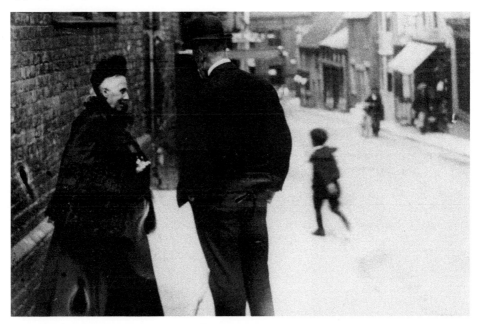

**Mrs Sharpe and the Town Clerk, a Chance Meeting in Lion Street, c. 1907**
Mrs Sharpe was probably the wife of George Thomas Sharpe of Church House, Church Square, listed as a private residence from 1887 to 1911. Walter Dawes (1845–1930), a town clerk from 1882 to 1924, was a partner in the Rye firm of solicitors, Dawes, Son & Prentice, (courtesy of Beryl Hutchings).

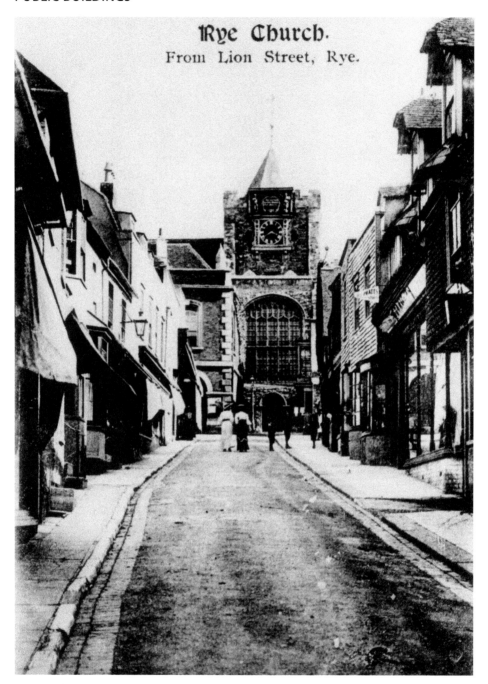

**St Mary's Parish Church from Lion Street, 1900s**

The church tower with its squat spire forms the summit of the hilltop town. The eighteenth-century Quarter Boys strike the quarter hours only – not the hours. All the shops on the left side of the street were occupied by Delves & Son. In descending order: a draper's, a china shop, a shoe shop, a furniture warehouse and a men's outfitters, (courtesy of David Padgham).

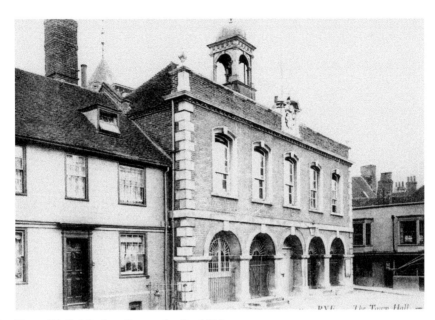

**The Town Hall, Market Street, in the 1900s**
Built in 1742 to the design of Andrews Jelf (architect of the first Westminster Bridge), this building was funded by a loan from the town's two Members of Parliament – a loan never repaid. In the 1900s, the first-floor rooms were used for council meetings and sessions of court. The ground floor, originally market, housed the borough's fire station and a magistrates' office, (Courtesy of David Padgham).

**A Lady Drives Out – The Corner of Church Square and Pump Street in the 1900s**
The vehicle is a phaeton, with space for shopping and an umbrella. The lady bears a resemblance to the Mrs Sharpe in the photograph on page 11. This was the pitch of 'Blind Bob', a beggar found on many old photographs of the period, (courtesy of Rye Museum).

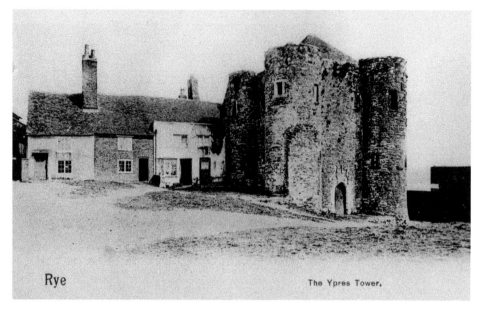

Rye                                    The Ypres Tower.

**The Ypres Tower and Adjoining Cottages,** *c.* **1900**
The common postcard subject was unusual in its relatively early date and wide angle of view. The tower was built in the fourteenth century and functioned as the town's jail from 1494 to 1891. The left-side pair of cottages were rebuilt soon after the date of this photograph, (courtesy of David Padgham).

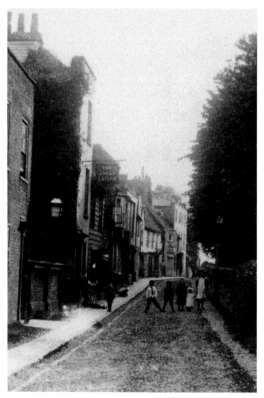

## COBBLED STREET

### The South Side of Church Square, *c.* 1900
This was traditionally a poor part of the town. In common with other streets, nineteenth-century development had been carried out behind the medieval houses. The urchins may have lived in one such development, Hucksteps Row, a slum area partly cleared during the 1920s when the façades were rebuilt in a timber-framed style. The lantern on the left belonged to the police station, built in 1891 and in use until 1966. The Jolly Sailor was a boarding house for itinerants, (courtesy of Frank Palmer).

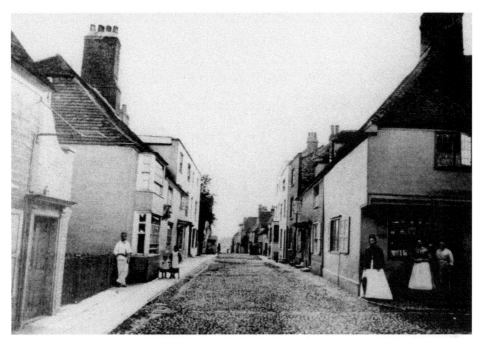

**The Junction of Church Square and Watchbell Street,** *c.* **1860.**
Well known as one of Rye's cobbled streets, Watchbell Street ran along the edge of the hill, allowing far-reaching views for defensive purposes. The shop on the right was occupied by Mrs Sarah Ruby from the 1850s, evidently as a grocer's – the goods visible in the window included Fry's Cocoa, (courtesy of Rye Museum).

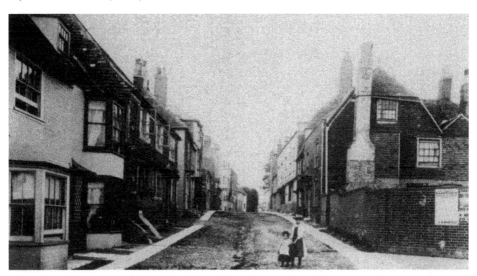

**Watchbell Street Looking East, 1890s**
The channel in the centre of the street indicates the lack of piped surface-water drainage in a mainly residential street. In the far distance is Rye's Methodist Chapel, bombed during the last war. The posters advertise the following respectively: Col A. M. Brookfield, successful Conservative candidate in the 1892 and 1895 parliamentary elections, and H. Horrell, a chemist, (courtesy of Hastings Museum).

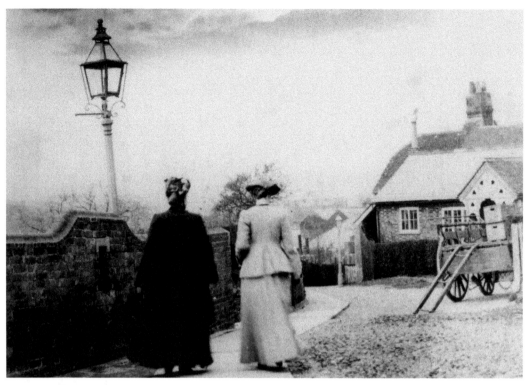

**Two Well-Dressed Ladies Out Walking at the end of Watchbell Street in the 1900s**
Although the buildings have disappeared, the scene is instantly recognisable. Gas lighting was provided in the town from at least the 1850s. The Jubilee Almshouses were converted from cottages by public subscription in 1897,. (courtesy of Beryl Hutchings).

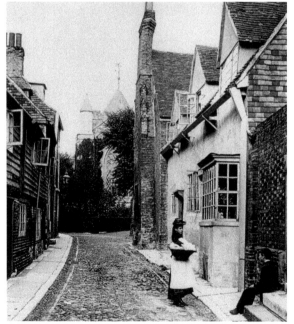

**West Street in the 1890s**
A well-known landmark, the crooked chimney was added in the sixteenth century to Grene Hall, later used as the town's customs house. The garden wall on the right was that of Lamb House, home of the Lamb family, who dominated Rye's political life in the eighteenth century. Note the wooden eaves gutters, (courtesy of Rye Museum).

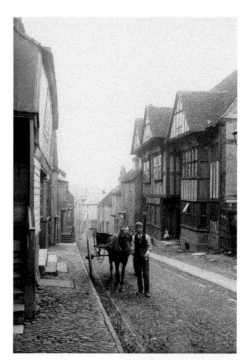

**Mermaid Street in the 1890s**
The fine house on the right of this steeply sloping street was built in 1576 and was later the home of Samuel Jeake II, a seventeenth-century scholar and diarist. The building further down on the left with steps and railings was the mid-eighteenth-century Baptist chapel. Jeake's store house adjoined on the left and still bears an astrological chart for the date of its foundation in 1689, (courtesy of Hastings Museum).

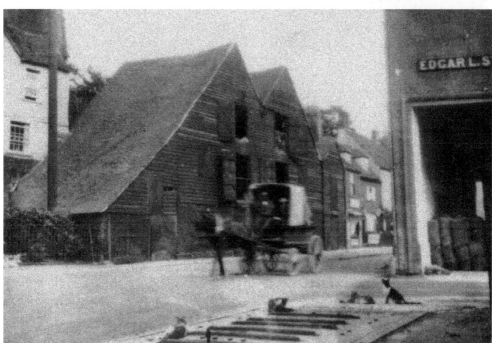

**The Strand in the Days of Horse-Drawn Transport,** *c.* **1920**
The timber building was the Old Ship's Stores, built in the eighteenth century and occupied, until its collapse in the 1920s, by Henry John Gasson & Sons, government contractors. The other warehouse belonged to the corn merchant Edgar L. Stonham. The cats lying on the weighbridge were no doubt useful in controlling rats, (courtesy of Rye Museum).

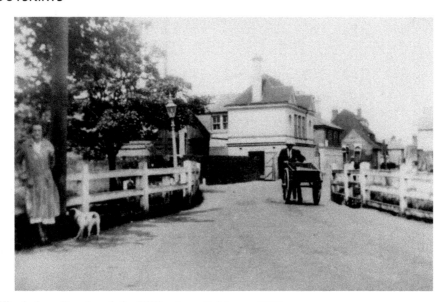

**Winchelsea Road and the Tillingham Bridge,** *c.* **1920**
The lock was the tidal limit of the River Tillingham and was rebuilt, with a wider bridge, in the early 1920s. The building was the showroom, boardroom and offices of the Rye Gas & Coke Co. Ltd, founded in 1839. The manager's house lay on the right and the gasworks to the rear, (courtesy of Nellie Goodwin).

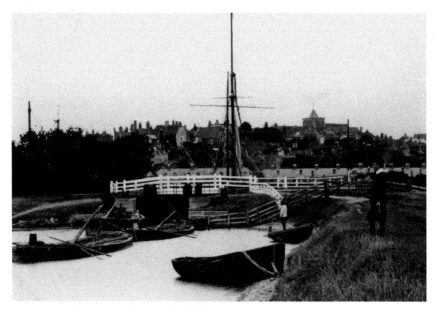

**The Brede Bridge and Sluice in the 1890s**
Situated on the road to Rye Harbour, this was the tidal limit of the River Brede, navigable for barges as far as Brede Wharf. The mast in the centre of the photograph is that of a trading vessel which has been manoeuvred into the approach to the sluice by ropes and warping posts in order to allow her to turn round and sail out of the harbour, (courtesy of Hastings Museum).

**Ferry Road on a Wet Day in the 1910s**

This was the route to battle via the Udimore Ridge. The road had been the centre of a small suburb since the sixteenth century – a house of this date was discovered in the 1980s in this area. The four businesses shown include George Henry Saddleton, a butcher who traded briefly in the 1910s, Harry Norman Chester, a boot repairer and Blackman & Baker, builders, contractors and undertakers – a firm established in the 1900s, (courtesy of Peter Ewart).

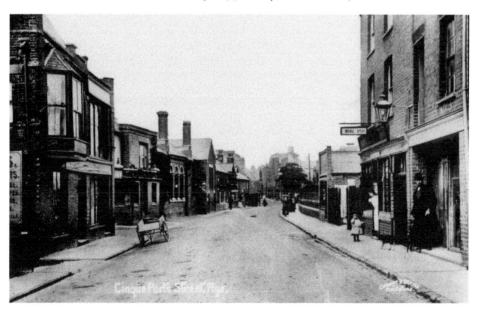

**Cinque Ports Street,** *c.* **1915**

Rye's secondary commercial street was greatly developed in the nineteenth century. The building on the left belonged to Ellis Bros, builders, monumental masons and builders' merchants. Beyond were the Cinque Ports Hotel and assembly rooms (with the pair of chimneys). On the far right of the picture Thomas Gasson's Furniture Stores can be seen, (courtesy of John Bartholomew).

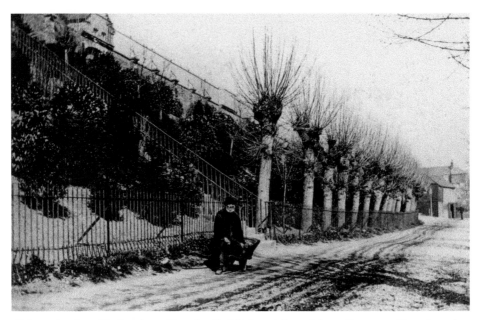

**Fishmarket Road Before 1903, Showing Public Provision of Open Space and Landscaping**
The Town Salts were embanked in 1834 and appropriated as a recreation ground. On the opposite side of the road, the picture shows the parade and steps built in 1864/65 by the Corporation at Hilders Cliff, overlooking The Salts. The pollarded willows provided cuttings for further planting on The Salts in 1855, (courtesy of Rye Museum).

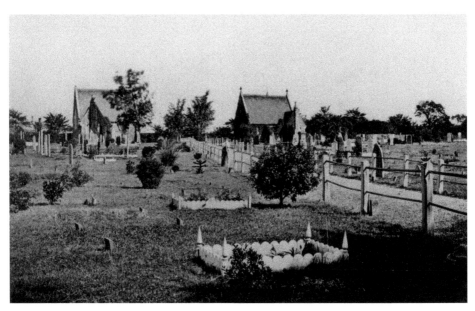

**Rye Cemetery,** *c.* **1880**
Opened in 1855 to serve both Rye and Rye Foreign, following closure of the churchyard at Rye, the cemetery was divided into two sections, each with a chapel – that for nonconformists on the left and that for Anglicans on the right. The ornate wooden kerbs have since disappeared. The fencing, against which a man is seen leaning, was removed before 1897, (courtesy of Rye Museum).

# Section 2
# The Port

Rye already possessed a major harbour, 'the Camber', in the sixteenth century. Silting and reclamation reduced its capacity and there has been a history of conflict between maritime and landed interests. By 1898 the harbour was governed by a commission composed of town councillors, householders, shipowners and land-drainage representatives. The commission had to struggle to keep the channels clear despite revenue from a busy coasting trade in coal, corn, timber, shingle and hops. The Rye shipyards were renowned for the quality of the sailing-trawlers that they supplied to North Sea ports.

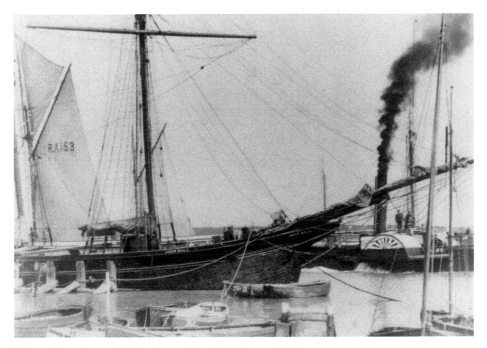

**Three Vessels on the Rother at Rye Harbour,** *c.* **1900**
In the foreground is the *John Bull*, sails furled, is and moored against piles. A fast coasting schooner, she was nearly too large for the harbour. Behind, the *Three Brothers* (RX153) can be seen sailing upriver. This was built in Rye in 1896 as a sailing-trawler; she was later converted to a cruising-yacht. The paddle-steam trawler on the right, *Crusader* (16RX), was built in 1875 and bought in 1884 by a consortium of Rye merchants before being broken up in 1904, (courtesy of Hastings Library Ray Collection).

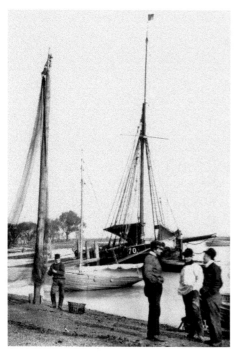

**The Fishmarket in the 1890s**
The pole was probably an old ship's mast used to suspend nets for drying and repair, an activity also recorded at Pole Marsh, Ferry Road. RX70 was one of the larger Rye sailing-trawlers, with a beam trawl hung over her starboard side. The small boat was possibly a pleasure craft. The fishermen are seen wearing the jerseys and bowler hats, common among boatmen of the time, (courtesy of Hastings Museum).

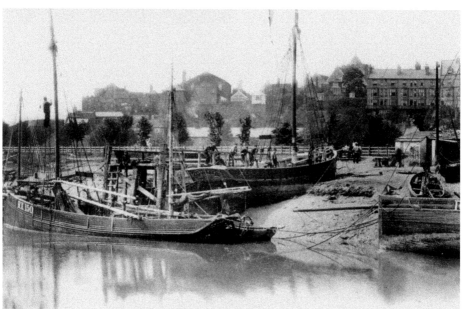

**Sailing Trawlers at the Fishmarket, *c.* 1900**
The rigging of RX150 is here seen undergoing repair. In addition the photograph includes no fewer than fourteen fishermen grouped on the bank and the landing stage, reflecting a late nineteenth-century harbour commissioner's complaint that 'the fishing smacks are getting more numerous, more troublesome, less under control', (courtesy of Rye Museum).

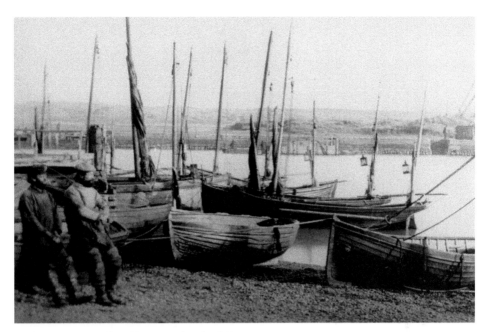

**Sailing Punts at Rye Harbour in the 1890s**
The punts were small, open fishing boats used by the poorer fishermen for all types of fishing, including long lining. Some carried oars, hung over the sides, and oil lamps for night-time drift netting. The boats were lug-rigged, with the sail fore of the mast, (courtesy of Hastings Library Ray Collection).

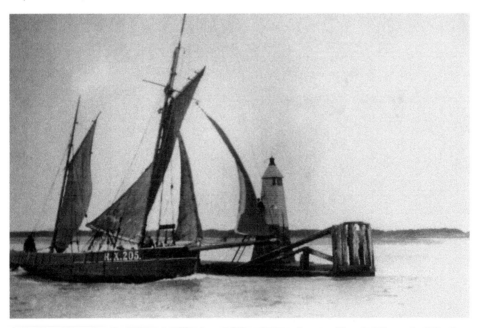

**A Sailing Trawler Leaving the Harbour Mouth in a Strong North-Westerly Wind**
The boat was a ketch, with fore and mizzen masts, gaff-rigged to provide manoeuvrability in the river. Such vessels continued in service until around 1930, when the industry was hit by the economic slump, (courtesy of Rye Museum, Band Collection).

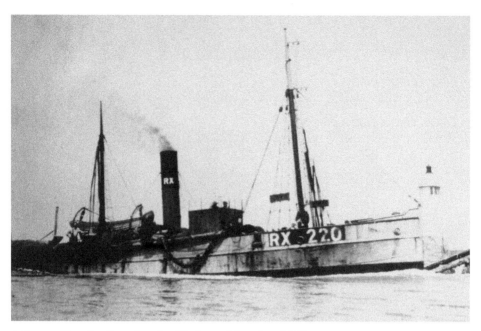

**A Steam Trawler Leaving the Harbour Mouth,** *c.* **1920s**
Steamers first appeared in the Rye fleet in the 1880s and became more numerous after 1900 – to the annoyance of the becalmed Hastings fishermen. In common with the sailing trawlers, steam vessels disappeared around 1930. The fleet reappeared with smaller, diesel-powered boats after the Second World War, (courtesy of Rye Museum, Band Collection).

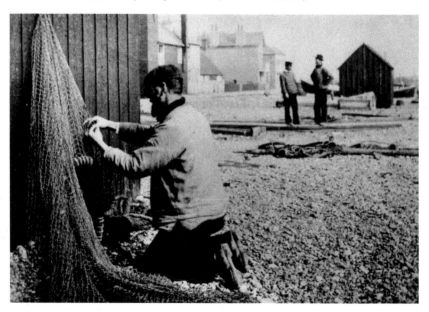

**Mending a Trawl Net at the Point, Rye Harbour,** *c.* **1900**
The village grew up in the early nineteenth century at what was then the mouth of the Rother, when high tides extended to the buildings on the left. These early buildings included the Ship Inn and, on the left, a Customs House, with watchtower and mortuary. The William the Conqueror, on the right, was opened around 1860, (courtesy of Rye Museum, Band Collection).

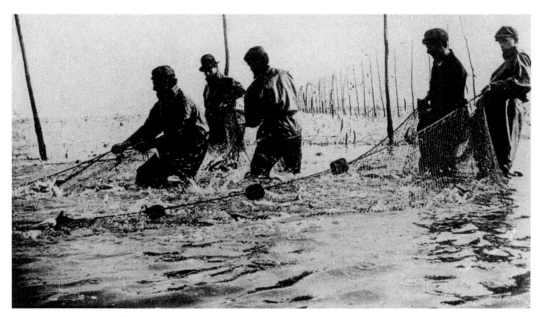

**Keddle-Net Fishing at Camber in the 1900s**

The nets were erected on flat, sandy shores between Romney Marsh and Pevensey to take advantage of the mackerel which swarm near the coast in the summer. Often operated by farmers, regular fishermen saw the nets as a hazard to boats and a waste of fish stocks. The nets were attached to stakes 11 feet high, set out in a straight line between high and low water marks. Fish encountered the obstruction and swam seawards to be caught in a circular pound. The industry died out around 1930 due to dwindling shoals and falling demand. Above: netting fish within the pound. Below: loading the catch into a high-wheeled cart, (courtesy of Rye Museum)

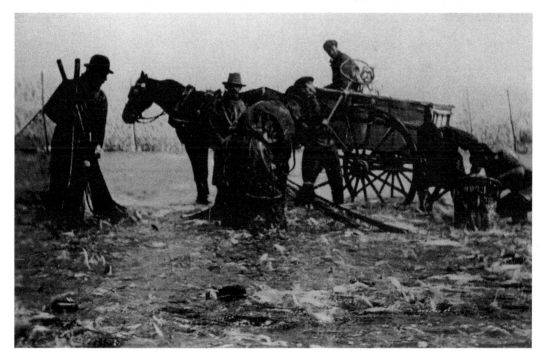

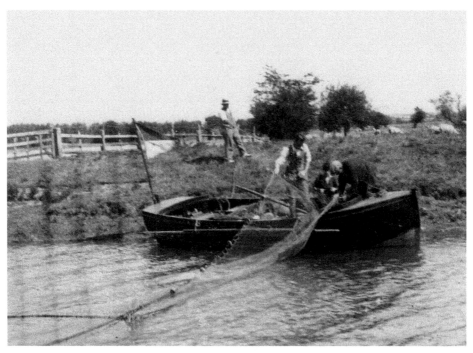

**Freshwater Fishing**
Netting grey mullet on the River Rother above Iden Lock in the 1920s, (courtesy of Barry Funnell).

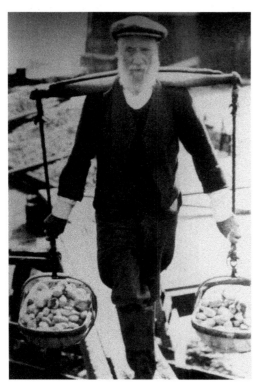

**Blue Boulder Picking at Rye Harbour,** *c.* **1919**
This was a low-paid, piecework industry which supplemented variable incomes from fishing. Blue flints, used in the pottery industry, were gathered on the shingle at Rye harbour and Winchelsea beach and brought to the railway at Rye harbour in small, gaff-rigged boats. The picture shows one such boat being unloaded by a member of the Cutting family, (courtesy of Rye Museum, Band Collection).

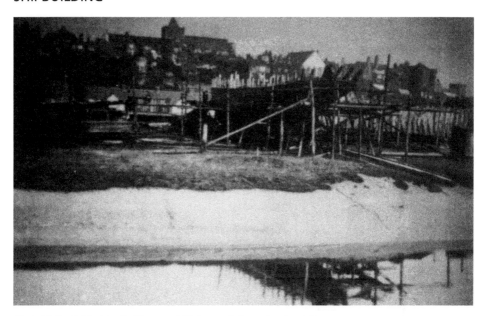

**G. & T. Smith's Rock Channel Shipyard, Rye, in the 1900s**
A major industry in the town, shipbuilding reached a peak in the late nineteenth century, employing several hundred men and building mainly sailing trawlers for the North Sea ports. It was said that 'Rye-built was a hallmark second to none', local oak contributing to the high quality of the ships. Hit by competition from irons trawlers, shipbuilding had almost disappeared in Rye by 1918.

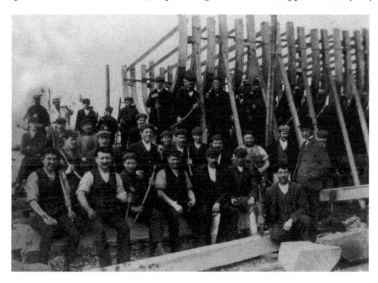

**Shipbuilders at G. & T. Smith's Yard at the End of the Nineteenth Century**
The men, proudly carrying the tools of their trade, were working on the frames for a Lowestoft trawler, (courtesy of Rye Museum, Band Collection).

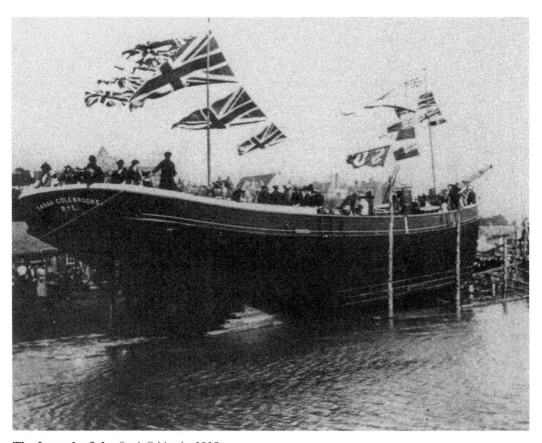

**The Launch of the** *Sarah Colebrooke*, **1913**

The event was reported by the *Hastings and St Leonards Observer* on 9 October 1913:

> Great interest was manifested at Rye last week in the launch of the auxiliary motor coasting vessel, *Sarah Colebrooke*. The craft is one of the largest, as well as the first motor propelled vessel ever laid down at Rye, and her construction is evidence of the progress of the shipbuilding industry of the Ancient Town. She has been built for the Mayor (Cllr W E Colebrooke, JP) by the well-known firm of Messrs George and Thomas Smith Ltd, Rock Channel Shipyard, and the christening ceremony was undertaken by His Worship's mother, Mrs Colebrooke, whose name the vessel has been given.

William Colebrooke (1856–1926) was a leading Rye coal merchant and shipowner. In the First World War the *Sarah Colebrooke* was used as a 'Q-ship' or anti-submarine decoy, being reinforced with sandbags and steel plates and armed with 3-inch guns, machine-guns and explosives. In one engagement a gun house was shelled but she returned fire within seconds with apparently lethal results, (courtesy of Beryl Hutchings).

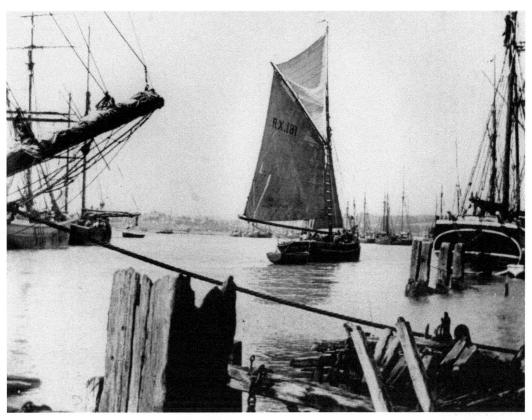

**High Water at Rye Harbour,** *c.* **1900**
A busy maritime scene showing a Rye trawler, *The Pert* (RX181), sailing past commercial moorings towards the fishing boats moored in the background. Of the two trading vessels on the left, one was a brigantine, with a square-rigged foremast and fore-and-aft-rigged main mast. The ship on the right was a Baltic trader, a barkentine, having three masts, one square-rigged. The cargo vessels were probably waiting to unload onto smaller barges or to moor at Rye, the unique silhouette of which is visible in the background, (courtesy of Peter Ewart).

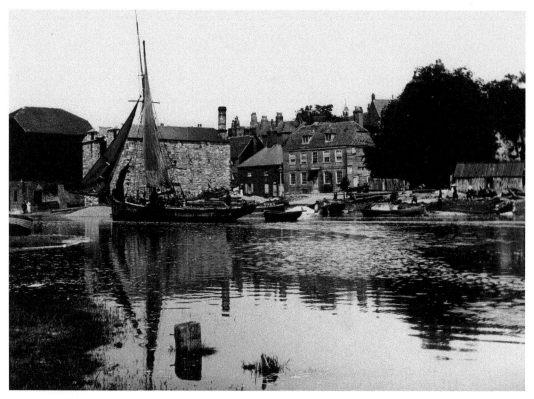

**High Tide at the Strand Quay, Rye, in the 1890s**

A charming study by George Woods, showing a fishing smack sailing up to the quay with her beam trawl hanging over the port side, past a large rowing boat and some smaller craft. A number of people were enjoying the scene from the shore, including several children clambering among the nets which had been spread out on the bank to dry. On the far left of the photograph can be seen one of Vidler & Sons' coal warehouses, built in 1804 by Lamb & Batchelor, timber and coal merchants. Next to it was the Grist Mill, built between 1771 and 1840 and occupied by Edgar L. Stonham, a corn merchant, from the late 1880s. In the centre was Strand House, then the home of Alderman John Holmes, a retired shipbuilder who served fifty-three years on the town council. The house was destroyed, along with adjoining buildings, in an air raid in 1942. The area to the right had formerly been Hessel & Holmes' shipyard. This photograph is also a reminder of the fact that boats may only enter and leave the harbour for a short period either side of the high tide, (courtesy of Hastings Museum).

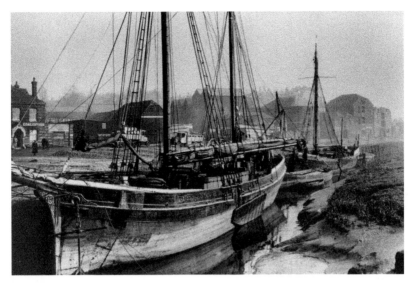

**Barges at the Strand Quay in the Late 1920s**
Two ketch-rigged coasting barges are shown moored at the quay, with a Rother barge between them. The *Mazeppa* hailed from Ipswich and traded in coal. Behind, two lorries appear to be unloading timber at T. Hinds & Sons timber and slate yard. Timber was stacked in the open on both sides of the road still known as The Deals. The tall buildings in the background were Stonham's corn warehouses, adjoining the harbour master's office on the quayside. To the right Vidler & Sons coal warehouses and the Grist Mill may be seen. The coal office on the left was built as Rye's customs house in 1855, remaining in use until the mid-1920s when the office moved to Cinque Ports Street, (courtesy of Rye Museum).

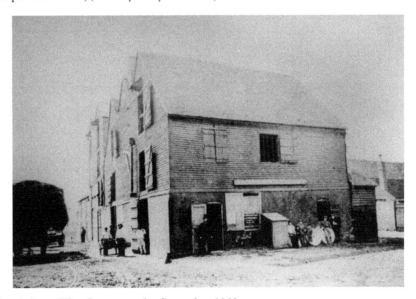

**Vidler & Sons Warehouse at the Strand, *c.* 1860**
Founded in 1820 by John Vidler, this firm was at one time Rye's leading general merchant and shipowner, occupying most of the warehouses at The Strand. The notice in the window reads, 'Lloyds Agent, Admiralty Receiver and Consulate (?).' The warehouse was probably built in 1736, (courtesy of Frank Palmer).

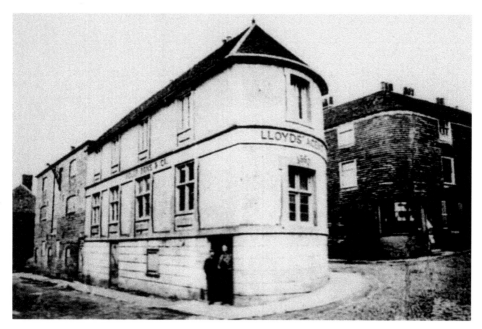

**Vidler & Sons Offices at the Strand**
The stove-pipe hat suggests that this photograph was taken soon after the offices were built in 1862. The firm sold off the corn side of its business in the late 1880s but carried on trading as coal merchants until the 1930s. The warehouse to the left was later used by H. J. Gasson & Sons for the manufacture of nets and tarpaulins, (courtesy of Frank Palmer).

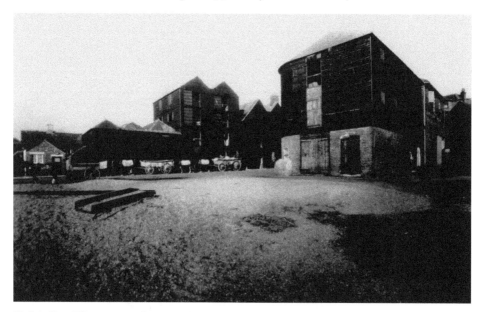

**Unloading Waggons at Stonham's Warehouses in the 1930s**
Grain was delivered by farmers for cleaning, storage or sale and hoisted by hand to the upper floors. The tall building was added to the Great Warehouse, on the right, around 1800, the remaining buildings dating from soon after. The photograph was taken after the conversion of the harbour master's office to public lavatories in the early 1930s, (courtesy of Rye Museum).

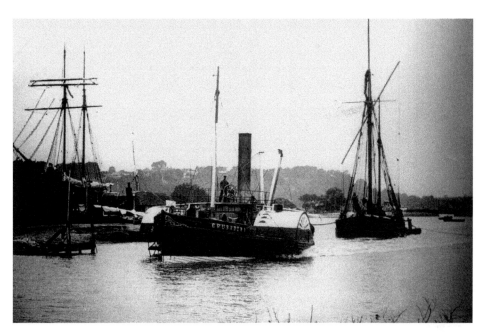

**The *Crusader* Towing a Laden Barge on the Rother near the Fishmarket,** *c.* **1890s**
The paddle-steam trawlers produced additional income by acting as tugs in the confined channel of the harbour. The vessel on the left was probably undergoing repair at the Rother Ironworks Co.'s patent slipway, (courtesy of Hastings Library Ray Collection).

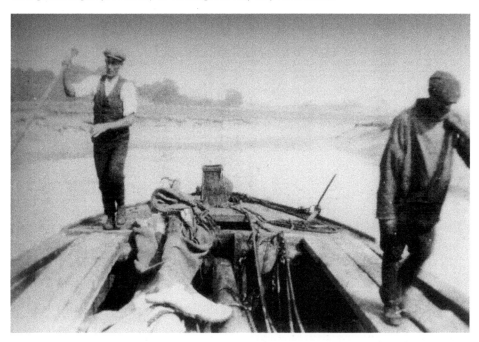

**Quanting a Rye River Barge on the Rother, Probably Near Scots Float Sluice, Playden, 1920s**
The barges were operated at this period by Vidler & Sons between Rye and Bodiam and on the River Brede. The mast was lowered across the hold, the sail being used only when the wind was favourable for sailing in a confined waterway, (courtesy of Rye Museum, Band Collection).

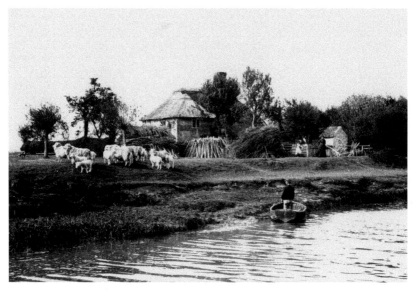

**The Rother Ferry, Near Northiam, in the 1890s**
It is believed that the ferry served a brickyard near the south bank of the river, the stacks of wood possibly being fuel for the kilns. The house was New Barn, on the north bank at Newenden in Kent. Note the mother and daughter with baby standing near the outside privy, (courtesy of Hastings Museum).

## FERRIES

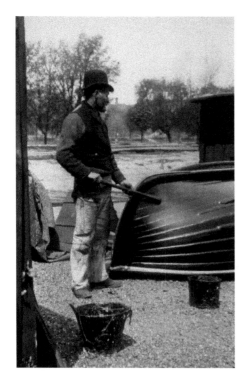

**The Rye Ferryman in the 1890s**
The ferry plied from the Fishmarket to East Guldeford and Camber before the building of the Monk Bretton Bridge in 1893. It also provided a shortcut for fishermen on their way to Rye Harbour. The ferryman, seen here tarring a rowing boat, was probably F. Page Snr, whose cottage survives at the southern end of the Fishmarket,
(courtesy of Hastings Museum).

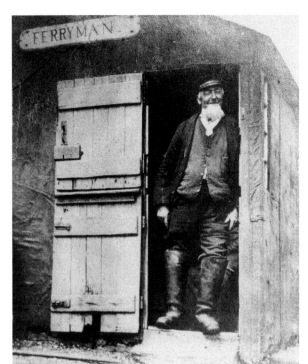

**The Rye Harbour Ferryman,**
*c.* **1920**
The ferry served the crews
of fishing and trading vessels
moored on both banks of the
Rother, in addition to visitors to
Camber. The ferryman is seen
standing at the door of his hut
wearing leather boots with iron
soles, (courtesy of Rye Museum,
Band Collection).

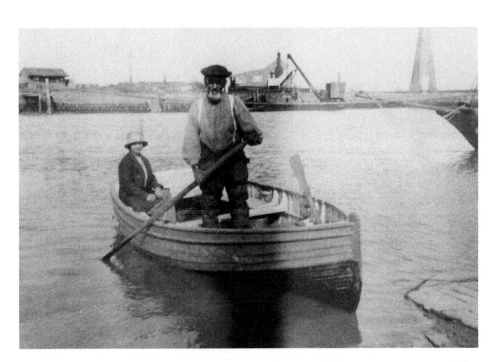

**The Rye Harbour Ferry,** *c.* **1923**
The ferryman ran two boats, the one illustrated having a keel for use at high tides, and the
other being flat-bottomed for low tides, (courtesy of Hastings Library).

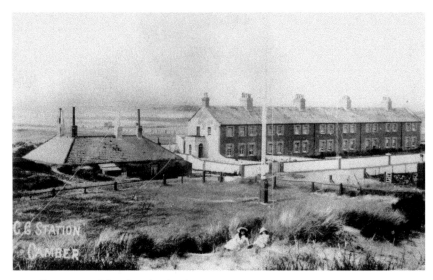

**Camber Coastguard Station in the 1900s**
The coastguard service employed a sizeable and mobile workforce, drawn from all over the country. The Camber station was built in 1866 and included a boathouse, watch house and an ammunition store. There were other coastguard stations at Winchelsea Beach, Rye Harbour and Broomhill; the Camber station closed around 1910.

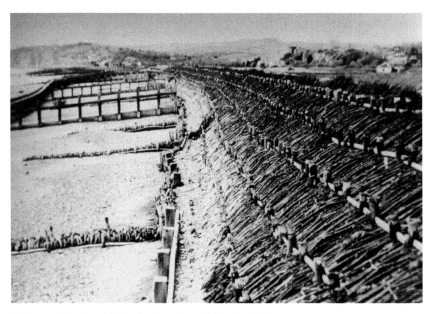

**Sea Defence Works at Winchelsea Beach in the 1940s**
Until the 1930s the foreshore had been protected by timber groynes and faggots, but several buildings had been lost to the sea. In 1934/35 a timber framework was built and filled with shingle. The photograph shows an example of faggot thatching, a traditional technique which was used to repair the defences before the present sea wall was built in the 1940s, (courtesy of Rye Museum, Band Collection).

# Section 3

# Rye at Work

In the horse-drawn age, the blacksmith, wheelwright and sadler were universal. Ironworking on a larger scale was also carried out in the town. Food-processing industries included breweries and made use of a multitude of windmills in the area. In the mid-1800s Rye was an important centre of a flourishing farming area and the hop growing industry left a permanent mark on the landscape in the form of conical oast houses. Cattle farming and fruit growing increased with the decline of hops later in that century. Woodland in the hinterland of Rye provided winter employment and materials for many uses including building, shipbuilding and tanning. Newer industries of tourism and the arts are also represented in the photographs.

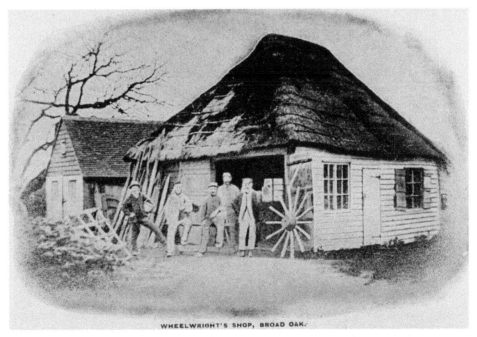

WHEELWRIGHT'S SHOP, BROAD OAK.

**Wheelwright's Shop, Broad Oak, Brede, in 1903**
Stephen Martin was listed in 1905 as a wheelwright, agricultural engineer and assistant overseer, a paid part-time office under the Poor Laws. By 1934 Martin and Ashdown had added building and decorating to the business. The Wheelwrights shop was a popular meeting place for farmers to discuss parish affairs, (courtesy of Eric Offen).

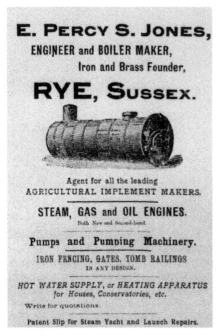

## E. PERCY S. JONES,

### ENGINEER and BOILER MAKER,

Iron and Brass Founder,

# RYE, SUSSEX.

Agent for all the leading
AGRICULTURAL IMPLEMENT MAKERS.

## STEAM, GAS and OIL ENGINES.

Both New and Second-hand.

### Pumps and Pumping Machinery.

IRON FENCING, GATES, TOMB RAILINGS
IN ANY DESIGN.

*HOT WATER SUPPLY, or HEATING APPARATUS
for Houses, Conservatories, etc.*

Write for quotations.

Patent Slip for Steam Yacht and Launch Repairs.

**Advertisement for the Rother Ironworks
from a Trade Directory of 1907**
The business was founded in 1863 and soon
suffered financial loss after starting a marine
department, although their two iron ships
were considered to be of 'excellent design,
adaptability, and seaworthiness', due to the skills
of the manager, Samuel Clark, inventor of the
twin-screw. The firm was bought in the 1880s by
the then manager Percy Jones and closed in the
1990s, (courtesy of Basil Jones).

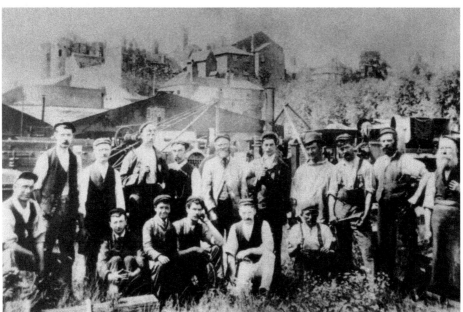

**Staff at the Rother Ironworks,** *c.* **1887**
The photograph shows the rear of the foundry buildings at the junction of Fishmarket Road
and South Undercliff. The works had departments for founding, forging, fitting, machining,
pattern- and boiler-making with a Patent Slip for ship repairs. In the background are the Gun
Garden, Ypres Tower and Inn, and the back of the Methodist chapel, (courtesy of Rye Museum,
Band Collection).

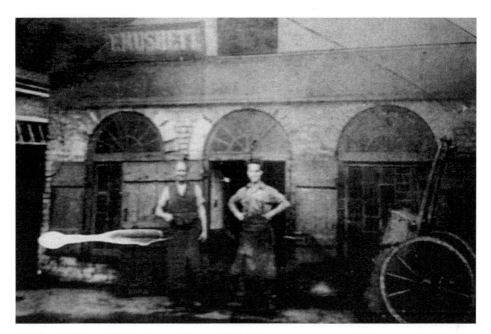

**Mushett's Forge, Wish Street, Rye,** *c.* **1930**
The forge was marked with a distinctive overhanging canopy on a map of 1859. It was run from the 1890s as part of the business of Richard Milsom, 'General and Manufacturing Ironmonger, Blacksmith, Gas and Water Fitter, Metal-plate Worker, Gunsmith and Ammunition Dealer', based at Nos 28 and 29 High Street. By 1924 it had been leased to Frank Mushett, (courtesy of Frank Palmer).

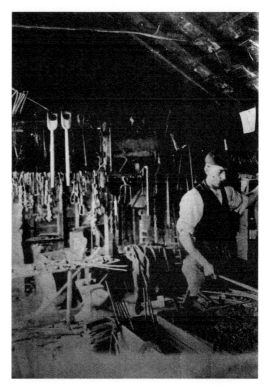

**Forge Interior at Brede in the 1920s**
One of two blacksmiths in Brede in 1905,
William Horton, was still in business in
1934, by which time a new generation
of metalworkers was represented
by H. C. Hartnell Ltd, 'Automobile,
Agricultural and General Engineers',
(courtesy of Eric Offen).

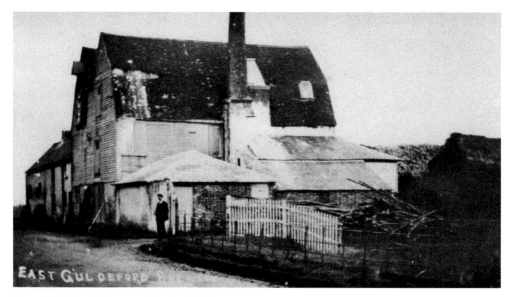

**East Guldeford Brewery in the 1900s**
Established by the Lamb Family in the eighteenth century, Chapman's Brewery was situated on the Rother at Military Road, just within East Guldeford. Other breweries included Bowen's at Landgate and, until the 1840s, Meryon and Holloway's at The Strand. The introduction of the railway led to competition from outside breweries, and Chapman's was demolished in 1911, although part of it remains as a tennis clubhouse.

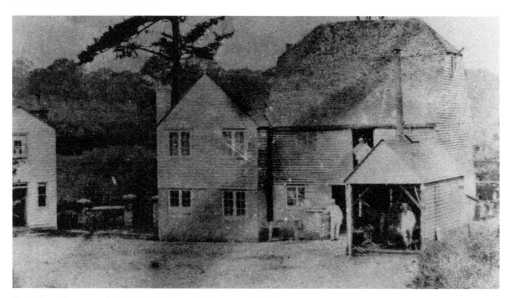

**Beckley Furnace Mill in the Late Nineteenth Century**
A watermill was recorded at this site just within Brede from the sixteenth century, functioning as an ironworks from 1650 to 1796. The corn mill was built around 1805 and run by three generations of the Miller family until its destruction by fire in 1909. There appears to have been a steam engine for periods of drought, (courtesy of Beryl Hutchings).

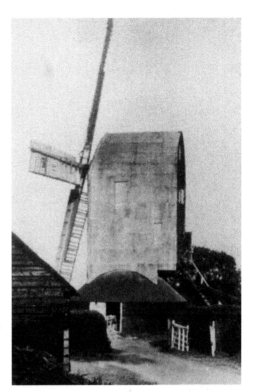

**Playden Windmill,** *c.* **1905**

Dating from the early nineteenth century, the mill was a post windmill, the whole building revolving around a post which was set on a framework within the roundel. A mound and former bakehouse relating to two other windmills on Rye Hill have survived nearby. The Playden Mill was worked, with a bakery, by Edgar Thorpe until 1915, when the assistant, Arthur Luck, left for war service. It was demolished to make way for a new house in 1952.

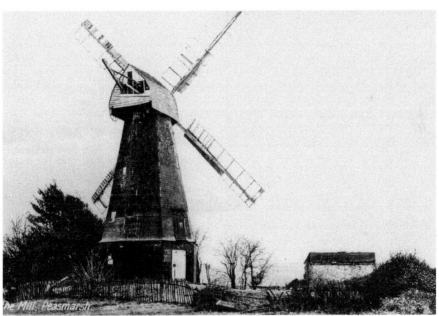

**Peasmarsh Windmill in the 1900s**

Situated at Flackley Ash, this mill was of the later 'smock' type, less numerous in this area, where only the cap revolved to face the wind. Operated in 1905 by Charles J Banister, with a bakery and mill at Northiam, the Peasmarsh Mill was demolished before the First World War, (courtesy of John Bartholomew).

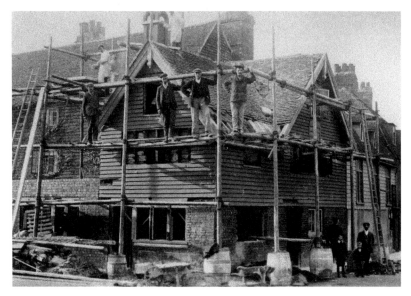

**Alterations at the Pipemarker's Arms, Rye, *c.* 1907**
Situated at the junction of Wish Street and Wish Ward, this building was recorded as a public house from 1844. It is seen here undergoing a facelift with two Edwardian gabled bargeboards replacing the earlier hiplets. The cottages on the left were largely destroyed by bombing in the Second World War. Note the timber and rope scaffolding resting in barrels, (courtesy of John Bartholomew).

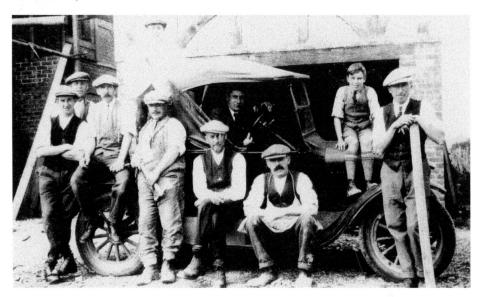

**Employees of Ellis Bros at Iden in 1925**
Including on the left, Frank Caister, a carpenter, and on the right, Will Caister. The men were building Burnt Oak Manor at Boonshill Lane for Lewis Linnett, a London accountant – a reminder of the additional business provided after the 1900s by high-class residential properties, many for weekend and holiday occupation only, (courtesy of Ernie Burt).

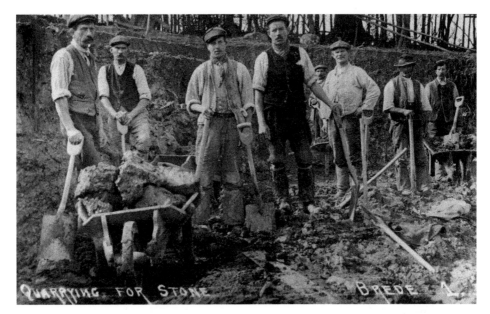

**Quarrying For Stone at Brede,** *c.* **1900s**
In addition to timber, many farms provided building materials as a sideline, including bricks, tiles
and lime. In 1934 Gerald Baker was listed at Reysons Farm as a 'farmer and blue-stone quarry
owner; crazy paving, rockery and road making stone'. The stone was probably the hard 'Tilgate
stone' found in the Wadhurst Clay, (courtesy of Eric Offen).

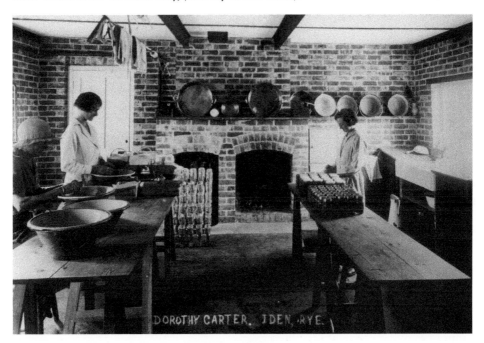

**Dorothy Carter's Jam Factory at Iden,** *c.* **1930s**
The business was started at Miss Carter's parents' house in Iden before the First World War. It
later moved to a cottage at Rye Foreign and occupied half of the old mission room as a jam store.
The stillroom at Iden was built in 1929, (courtesy of Gurtrude Coleman).

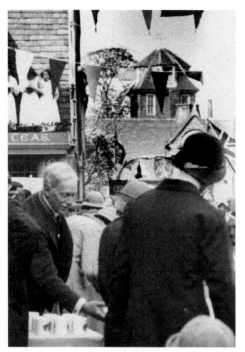

### E. F. Benson Distributing Jubilee Mugs Outside the Town Hall, 1935

Edward Frederick Benson (1867–1940) was one of many literary figures who lived in Rye; others included Henry James, Radcliffe Hall, and Conrad Aiken. Benson lived at Lamb House and was the author of several books including the satirical *Miss Mapp* novels, which depicted life in the town. He was Major from 1934 to 1936. The building in the background was a five-storey gazebo built in the grounds of Tower House, West Street, in 1768, (courtesy of Frank Palmer).

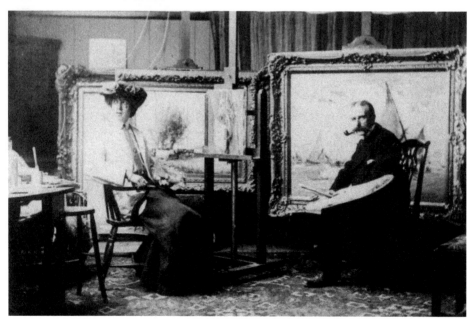

### Howard and Mary Stormont at their Studio in Rye, *c.* 1910

Among artists associated with Rye were the Stormonts who lived and worked from 1898 at Ypres Studio, Ockmans Lane, painting rural and maritime scenes and exhibiting at the Royal Academy. Mrs Stormont endowed the Rye Art Gallery, opened at her former home in 1965, (courtesy of Basil Jones).

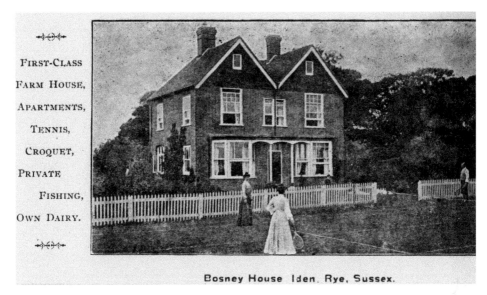

A Country Guest House, Bosney House, Iden, *c.* 1900

Rye became popular as a weekend and holiday area, especially after the opening of the golf course in 1894. In addition to the appearance of guest houses, public houses increasingly offered accommodation for visitors, cyclists and motorists, (courtesy of Gurtrude Coleman).

Waiting to See the Fresco, 13 July 1910

From the late nineteenth century, visitors were increasingly attracted to Rye by its history and archaeology. The Fresco was discovered in 1905 at the sixteenth-century Flushing Inn, Market Street. The photograph shows members of the Hastings and St Leonards Natural History Society on an excursion to Winchelsea and Rye, (courtesy of Hastings Library).

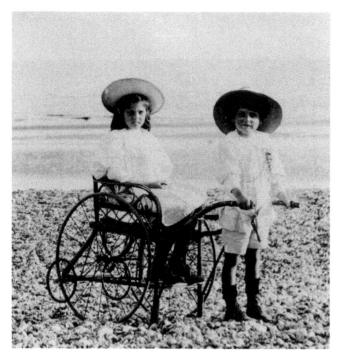

**The Seaside**
On a beach near Rye, *c.* 1900s, children appear to be playing with a younger sibling's perambulator. Camber Sands and Winchelsea Beach became popular seaside destinations, and bungalow settlements grew up, especially from the 1920s, (courtesy of Rye Museum).

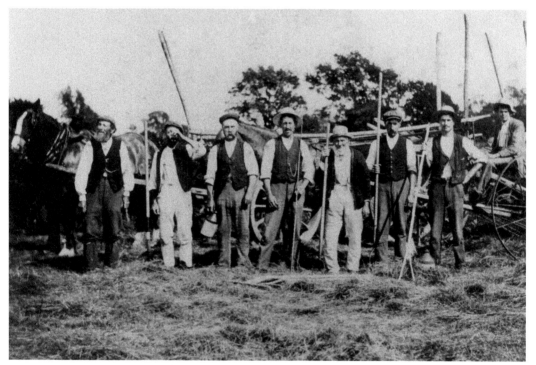

**Haymarking at Iden,** *c.* **1900s**
A large workforce gathered for this photograph, with liquid refreshment being provided in a stoneware jar. The contraption on the right was a horse-drawn rake, presumably for turning the hay for the last time before loading into the waggon, (courtesy of Mrs Wood).

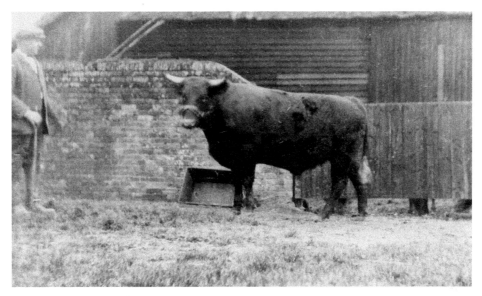

**A Show Bullock at Iden, 1900s**
The photograph shows Richard Coleman (1856–1935), farm bailiff to Bertram Ramus at Elms and Bosney Farms. A tenant on the Iden and Playden Estate, Ramus, was allegedly dispossessed by the agent due to a disagreement between their wives. The holding was regarded as a model farm, all gates and hedges being kept in order and wet weather work provided for the men, (courtesy of Gurtrude Coleman).

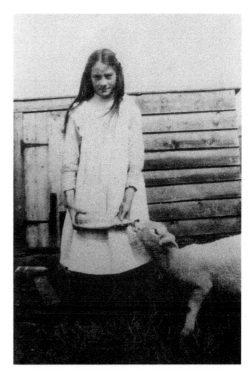

**Hand-Rearing a Lamb**
Gertrude Coleman hand-rearing a lamb at Bosney Farm in Iden, *c.* 1910, (courtesy of Gertrude Coleman).

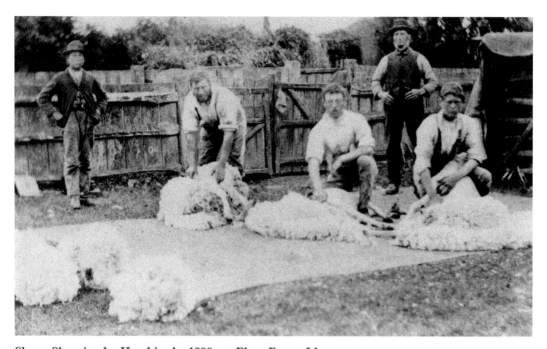

**Sheep Shearing by Hand in the 1890s at Elms Farm, Iden**
The tar-boy on the left treated sheep who were accidentally injured during the shearing, (courtesy of Gertrude Coleman).

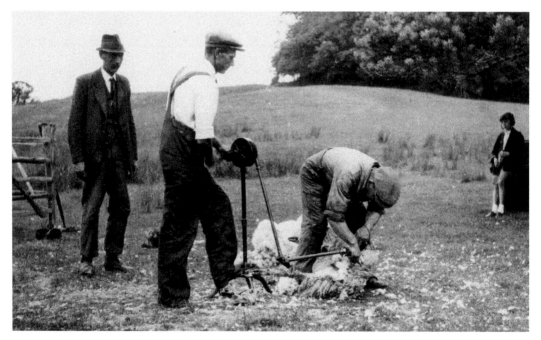

**Sheep Shearing by Machine, *c.* 1940s**
As a policeman (see page 78), Stephen Muggridge had long harboured a wish to retire into farming. This ambition was realised when he took the tenancy at Rolvenden Farm, Rye, on the Burra family estate, (courtesy of Frank Palmer).

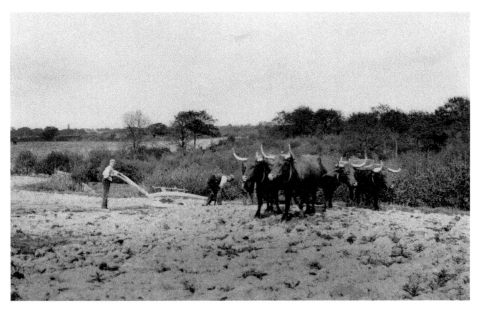

**An Ox Team Near Hastings,** *c.* **1890s**
Probably taken at Guestling, the smoke of an engine on the railway line can be seen in the background. Oxen were often used on the heavy clay soils of the Weald, being steadier than horses, (courtesy of Hastings Museum).

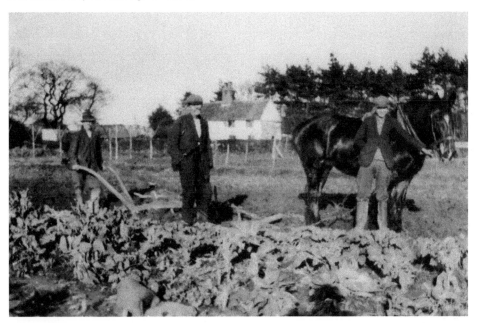

**Horse-Drawn Ploughing Near Randolphs Lane, Playden,** *c.* **1920s**
From left to right: Alfred Mills Billy Clark and Frank Wood. Blue Cottage in the background was built in 1794 and used as one of the poor houses for Playden before the union workhouse was built in 1844, (courtesy of Henry Dive).

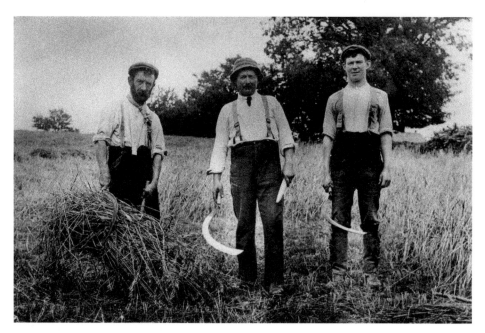

**Hand Reaping at Brede, _c._ 1920s**

The men were cutting oats with sickles, probably to make a road into the field for the reaping machine. Note the use of a stick to control the crop and prevent injury to the legs. The figure in the centre wearing a necktie and holding a sharpening stone was probably the farmer or foreman. The younger man on the right was Harry Redpath, (courtesy of Eric Offen).

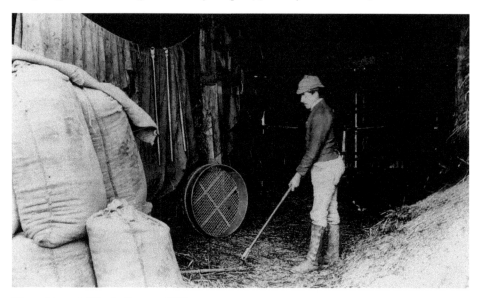

**Threshing at Winchelsea, _c._ 1890s**

The crop was stored as sheaves on one side of the barn and threshed on a timber floor in the centre, the doors normally being open to allow the chaff to blow away. Although steam threshing was increasingly common, threshing by hand was still carried out at Iden in the 1900s. The lettering on the sacks indicates that the farmer was Walter Fuller of Mill House, (courtesy of Hastings Museum).

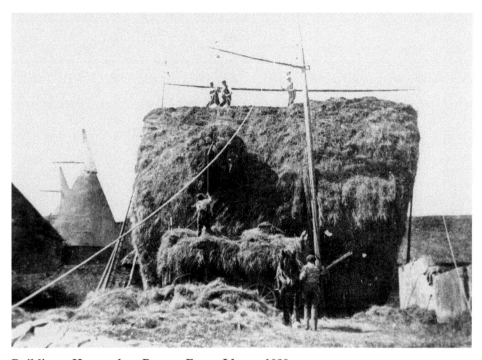

**Building a Haystack at Bosney Farm, Iden,** *c.* **1920s**
The horse-drawn hoist was devised by the farm bailiff Richard Coleman. The oast house in the background was disused after 1908, (courtesy of Gurtrude Coleman).

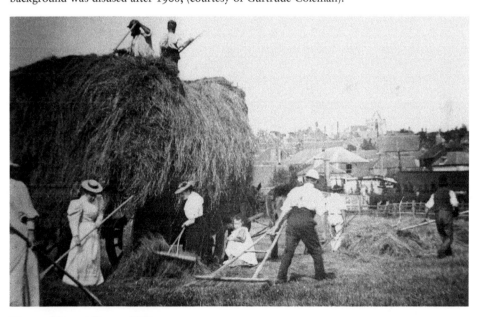

**Haymaking at Rye,** *c.* **1900s**
Nine people were at work including a well-dressed woman and a child. The land near Ferry Road was probably hired from the railway company for seasonal mowing and grazing. The large gable of Gasson's office and stores in Cinque Ports Street can be seen below the church, (courtesy of Rye Museum, Band Collection).

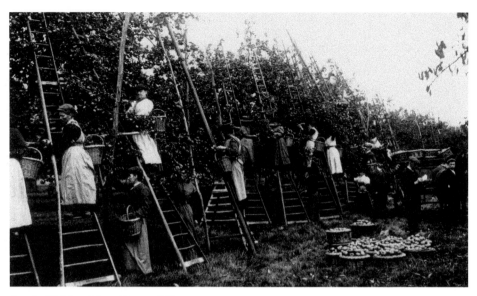

**Apple Picking Near Rye,** *c.* **1900s**
Fruit growing was not widespread in the Weald before the late nineteenth century. Note the wide ladders and timber scaffolding used for hanging baskets and to prevent damage to the trees. Baskets marked with the farmer's name were laid out for booking and removal in the horse-drawn cart, (courtesy of Rye Library).

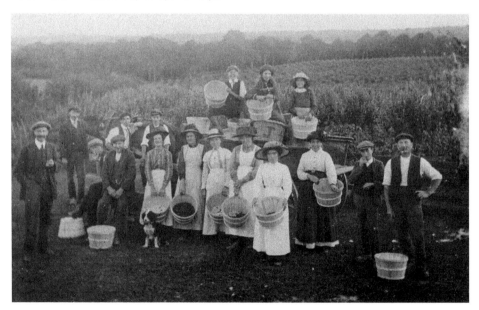

**A Happy Group of Blackcurrant Pickers at Flackley Ash, Peasmarsh,** *c.* **1900s**
The growing of soft fruit was labour intensive, employing as many women as men. The blackcurrants may have replaced hops on this land, the area of hops having declined nationally by more than half during the twenty-five years before 1909. Blackcurrants were also grown briefly during the 1900s at Bosney Farm, Iden, for the manufacture of dye, (courtesy of Dick Sellman).

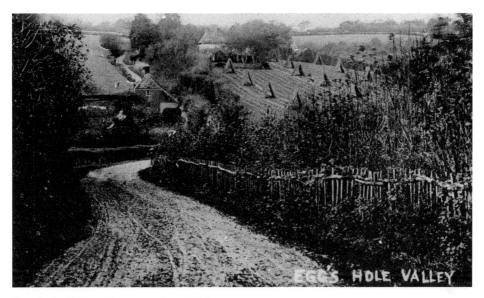

**Eggshole Valley, Peasmarsh, *c.* 1900s**
A hop garden can be seen on the opposite slope, the hop poles being stacked out of season. The hop plants lasted for around twenty years, being cut down to the ground each year. Individual poles were gradually replaced by permanent poles and wirework after the 1880s, (courtesy of Dick Sellman).

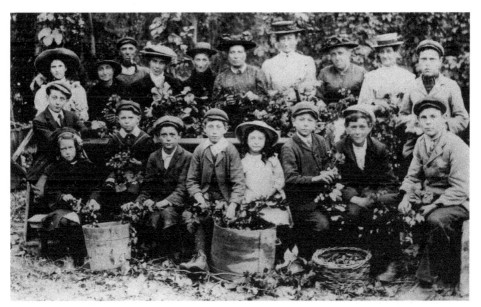

**Hop Picking, Probably at Icklesham in the 1900s**
Hop picking occupied four to six weeks between August and October and employed large numbers. The children shown are a reminder of the 'hop-picking holiday' from school, allowed later than normal in hop-growing areas. A mother and her children could earn enough to buy winter clothes, (courtesy of Winchelsea Corportation).

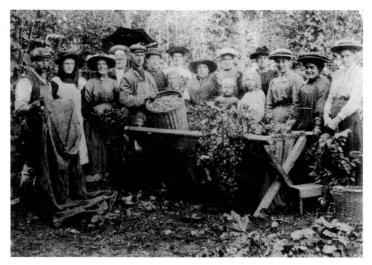

**Hop Measuring at Leasam Farm, Rye Foreign,** *c.* **1905**
The hops were picked by hand into bins at the hop garden, the poles being pulled up and laid flat for the pickers by 'pole-pullers'. The measurer scooped the hops into a bushels basket, the women often trying to charm him into packing the basket loosely to inflate the number of bushels recorded. The tallyman on the left is seen holding a ten-bushel bag, the 'poke' ready to receive the hops for transporting to the oast house. He recorded the number of bushels against the bin number in the book hung around his neck, and often provided the pickers with a wooden tally, notched according to the bushels picked. The umbrella in the background was carried for shade and also used as a receptacle for hops picked by children, (courtesy of Rye Museum).

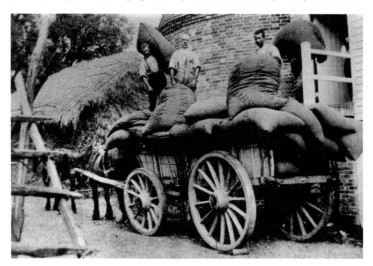

**Unloading Hops Into an Oast House, 1911**
The pokes were unloaded directly from the wagon into the first floor of the oast house, used as a cooling area after the hops were dried. The framework on the left was probably a rack to provide ventilation for pokes waiting for space in the oast house. The lettering on the pokes identifies the farm as Lea Farm, Rye Foreign (postal address Peasmarsh), occupied by Frank Reeve and bought by him at the sale of the Peasmarsh Place Estate in 1919. The 365-acre holding included 52 acres of hops – a large proportion for the period. The oast house was demolished in 1984, (courtesy of Rye Museum, Band Collection).

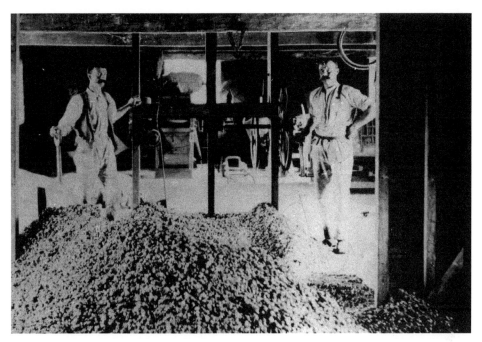

**Pressing Hops at Dinglesden Farm, Peasmarsh, 1903**
After the hops had been dried on a slatted floor over a charcoal furnace, a tall pocket was suspended from a hole in the cooling floor and the hops pressed in tightly. Originally this was done by a man treading inside the pocket, later by a mechanical press, (courtesy of Peasmarsh WI).

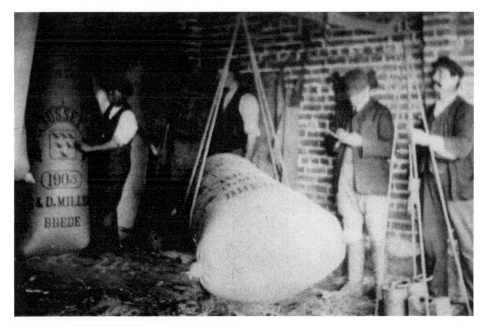

**Weighing Hops at Bankside, Brede, 1903**
The filled pockets were weighed in the stowage below the cooling floor. They were stencilled with details of the county (including the Sussex shield of six martlets), grower and year. In addition to farming, George and David Miller were wind and water millers in Brede, (courtesy of Eric Offen).

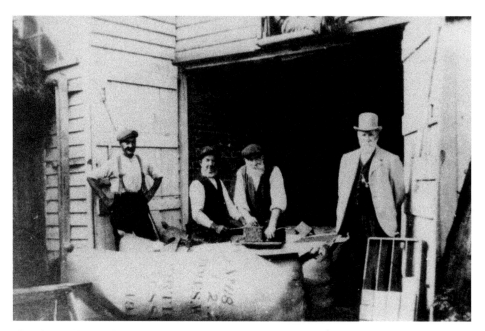

**Hop Sampling at Gotely Farm, Northiam,** *c.* **1910s**

Hop sampling at Gotely Farm, Northiam, for James W. Lord by Mr Tedham Snr. The sampler was a respected figure who travelled between farms, cutting open pockets and taking small samples which were trimmed into a neat block and transported to London for judging before purchase from the grower. The pocket was refilled, sewn up and reweighed, (courtesy of Northiam WI).

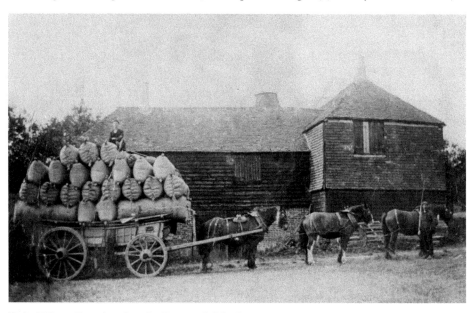

**Dried Hops Leaving for the Borough Market**

Dried hops leaving for the London Borough Market in 1912 from Stream Farm, Peasmarsh, on the Woodside Estate, occupied by Henry C. Noakes. His name is just visible on one pocket. Many growers turned the blank side of the pocket outwards to avoid giving information about their crop. The hops completed their journey by train or barge from Rye, (courtesy of Dick Sellman).

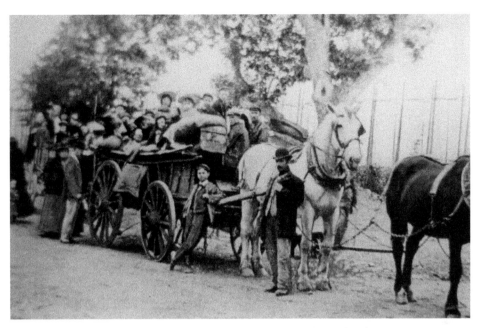

**Homeward-bound Londoners on Their Way to the Railway Station**
Hop picking was the annual holiday in Kent and Sussex for thousands of Londoners who made up the shortfall in local labour and who were often accommodated in permanent 'hoppers' huts'. At the end of the picking at Bosney Farm, Iden, in the 1900s, the hoppers went one by one up the steps of the oast house to be paid and to have a glass of gin, (courtesy of Rye Museum, Band Collection).

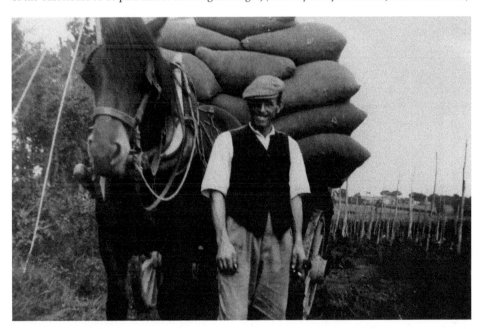

**The End of an Era**
Albert Paine in 1956, with the last load of hops to be taken to the oast house at Moat Farm, Iden, from traditional picking. After this date the hop bines were taken complete to a building for picking by machine, (courtesy of Albert Paine).

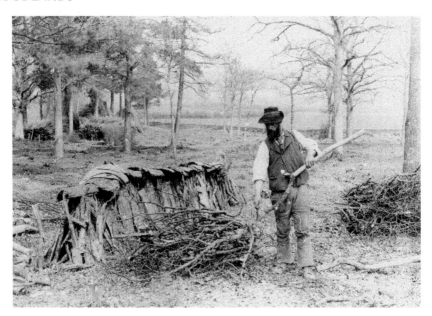

**Traditional Woodland,** *c.* **1890s**
A coppice with standards, cleared every few years to make the poles and brushwood stacked in the background. The standards, usually oak, were allowed to grow to maturity for building or shipbuilding purposes and produced bark (stacked in the foreground), which was used for tanning and was one of the main cargos sent from Rye. Bark was removed from poles to prevent beetle attack, (courtesy of Hastings Museum).

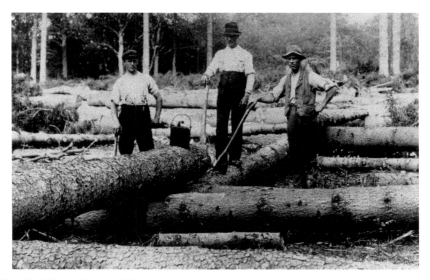

**A Conifer Plantation,** *c.* **1920s**
From left to right: farm workers Fred Catt, Charlie Catt and their father Will Catt are seen trimming the side branches from felled trunks. In contrast to the coppice, the land required replanting after felling. Woodlands provided additional employment especially in winter, (courtesy of Eric Offen).

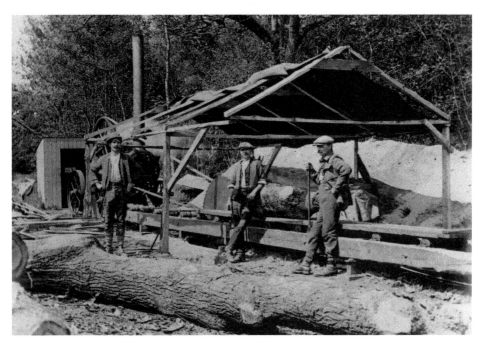

**A Steam Sawing Engine,** *c.* **1920s**
Members of the Crouch family, Brede woodmen, in Whiteland Wood, Westfield. From left to right: Norman, Will and Kay. The engine drove a circular saw by means of a long belt, the trunk being moved on planks laid over rollers, (courtesy of Eric Offen).

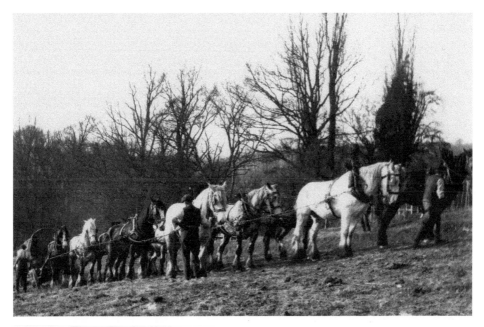

**A Timber Tug at Brede, 1930**
A team of eleven horses towing an Oak, four feet in diameter, past Brede Place on a 'tug', or low trolley. Such trees had been much used for shipbuilding in Rye and were transported by this method to the shipyards, (courtesy of Eric Offen).

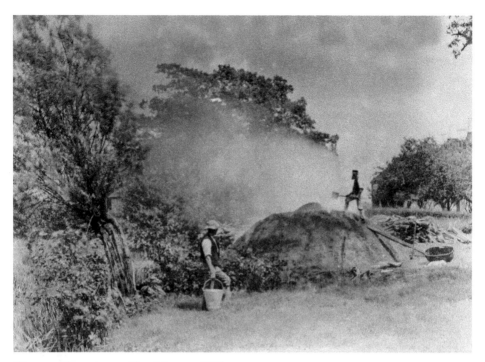

**Charcoal Burning at Northiam,** *c.* **1900**
Charcoal was used in hop drying and two oast-cowls can be seen in the background. The burners travelled between farms, covering a 'clamp', or mound of wood, with turf, moss and earth, and using buckets of water to keep it smouldering for several days without burning, (courtesy of Elizabeth Rigby).

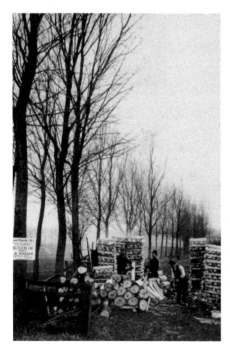

**Cricket Bat Willow at Northiam, 1911**
The trees had been planted at Crockers Farm, bought by James Moreton Lord, in 1900. The sign reads, 'Trees planted 1901, young sets selected by J W Stockdale, trees felled Nov and Dec 1911. J. W. Stockdale, Harold Wood, Essex.' Bats were made locally in Robertsbridge and the timber was also used to make Sussex trug baskets. The farm extended into the low-lying Rother Valley, (courtesy of Elizabeth Rigby).

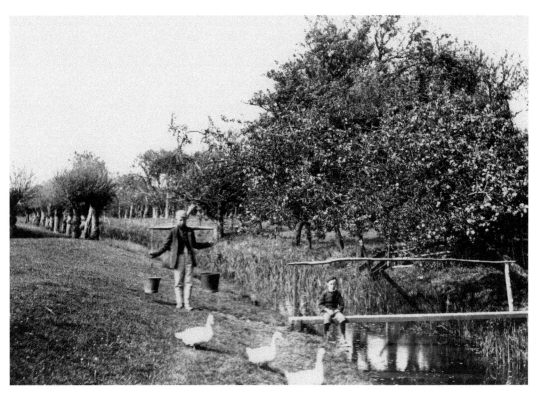

**Pollarded Willows at Northiam, 1890s**
The trees were cut around 6 foot above the ground to produce successive crops out of reach of grazing animals. They were planted beside water – a reminder that every resource on the farm was put to good use. The two boys and the ducks are seen by a shepherd's bridge, leading to an old orchard with new planting in the background, (courtesy of Hastings Museum).

# Section 4

# Commercial Life

Photographs abound of shops in Rye and the surrounding area, ranging from small traders starting in their front rooms to long-established businesses in the town serving the wealthier townspeople and farmers. The delivery of goods by hand or horse-drawn vans was a common feature. The arrival of multiple retailers is also recorded, while the growth of business empires in the towns such as Delves & Son has already been encountered on page 12. Inns and hotels existed in almost every street in Rye and the postal system provided a frequent, even same-day, service in the heyday of the postcard. There was an increasing need for professional services, especially estate agents who managed surrounding estates and catered for new residential demands.

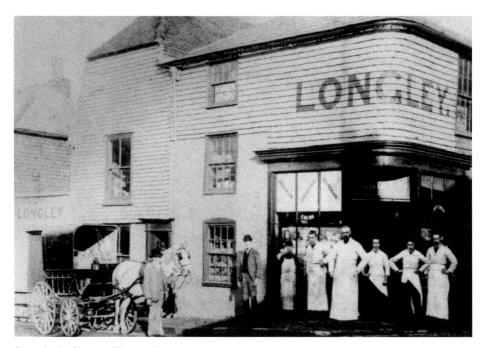

**Longley's Corner, Rye,** *c.* **1880**
Isaac Longley took over an established grocery business at the junction of Ferry Road and Cinque Ports Street in the 1860s. He is seen here with his staff and delivery van. A popular member of the Congregational Church, he died in 1899 during his year of office as mayor, the shop later being demolished, (courtesy of Frank Palmer).

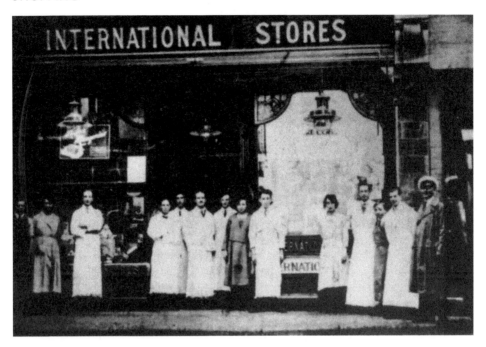

**The International Stores, Rye,** *c.* **1920s**
The International Tea Company was one of the earliest household names to become established in Rye, taking over a house at No. 87 High Street in around 1890. The firm rebuilt the premises and, after around 1910, also ran Longley's grocery shop at Ferry Road. *Above*: the manager Ernest Rhodes, staff and delivery man outside the High Street premises, (courtesy of Rye Museum, Band Collection). The van can just be seen on the right. *Below*: interior of the High Street store showing the long counters required for service of items by assistants, (courtesy of Frank Palmer).

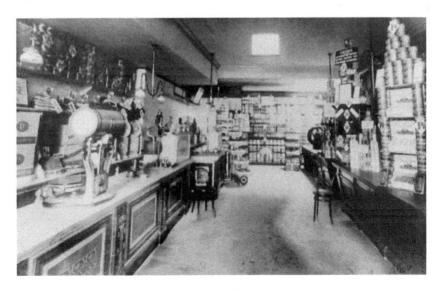

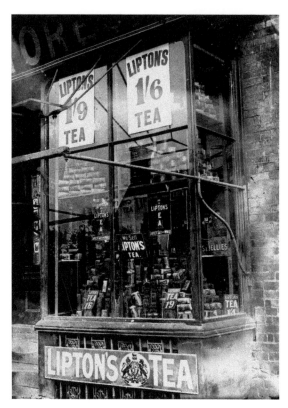

**A Lipton's Tea Display at Beckley Stores, 1900s**
An example of blanket advertising by a household name. The stores were run by William Maynard as a grocer's, linen draper's and post office in 1905. Note the worn steps to the shop door, (courtesy of Mary Howse).

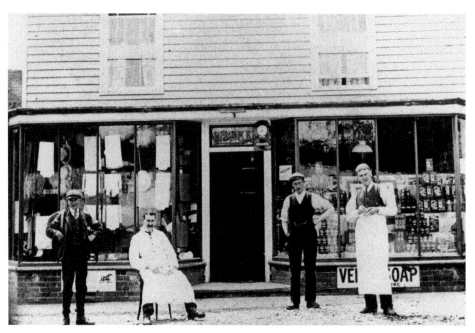

**Herbert Baker's Shop at Peasmarsh, *c.* 1900**
Another example of the common combination of grocer and draper at village shops. The shop was one of four groceries at Peasmarsh in 1905, (courtesy of Doug Smith).

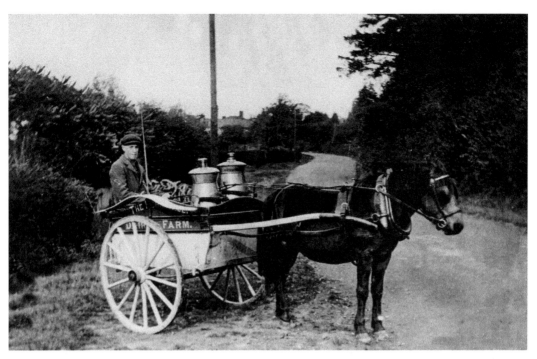

**Fred Crisford Delivering Milk for the Peasmarsh Dairy Farm, 1900s**
The vehicle was a float, entered from the rear and drawn by a small pony. Mrs Ellen Fuggle was listed as a dairy farmer at The Hermitage, on the Peasmarsh Place Estate, in 1905, (courtesy of Dick Sellman).

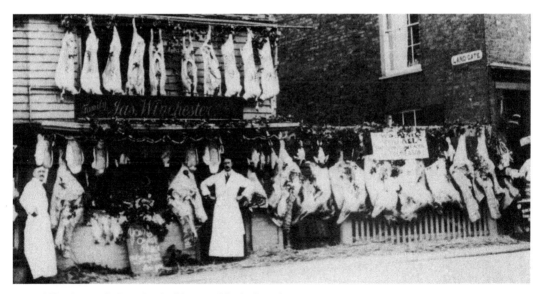

**Winchester's Butcher's Shop at No.16 Landgate**
The impressive display was for Christmas 1928 or 1929. An established butcher's shop, the business was acquired in the mid-1920s by James Winchester (centre). By 1934 the assistant, Herbert Cheeseman (left), had taken over (courtesy of Frank Palmer).

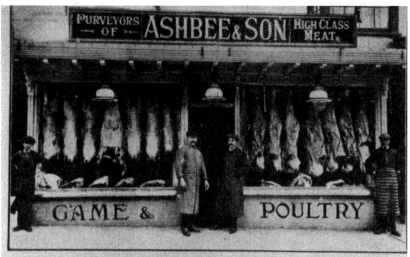

**Ashbee's Butcher's Shop at No. 100 High Street,** *c.* **1910**
Henry Ashbee started trading at Ferry Road in the 1880s before moving to No. 2 East Street and then to prime High Street premises in the 1900s. A butcher's since at least the 1850s, the High Street shop retains its splendid shopfront with canopy and hooks. Note the telephone number; telephones were introduced into Rye in 1904, (courtesy of Eleanor Brodrick).

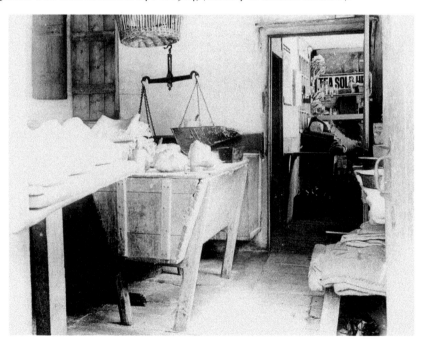

**A Baker's Interior at Winchelsea,** *c.* **1890s**
Although not identified, this photograph was found in a Winchelsea collection, and a bakery is indicated by the loaves, scales, sacks and the kneading trough with canted legs. Dry grocery goods such as tea were often sold by bakers. Andrew Johnson was succeeded as baker in Mill Road by James Homard during the 1890s, (courtesy of Hastings Museum).

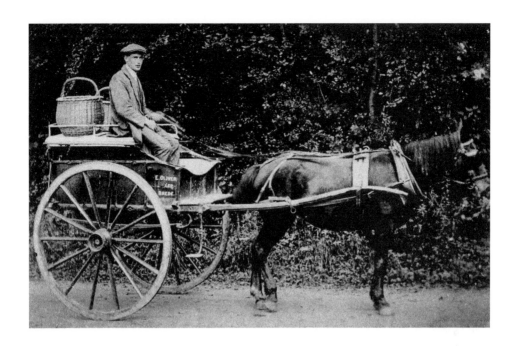

**Baker's Delivery at Brede**
Sid Cruttenden driving a dog cart for the Brede baker, Ernest Oliver, *c.* 1910, (courtesy of Eric Offen).

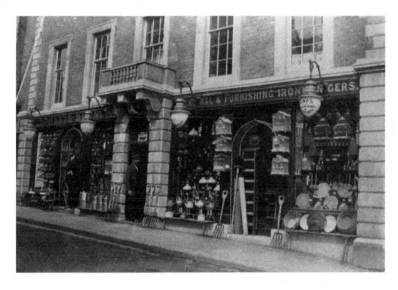

**Ellis Bros, Ironmongers, Rye,** *c.* **1906**
The business occupied substantial premises at the eastern end of the High Street, with an impressive entrance and double shop frontage. This site had been an ironmongers since the mid-eighteenth century when David Guy gave his name to Guys Cliff to the east, subsequently named Hilders Cliff after the nineteenth-century ironmongers. The shop was taken over by Ellis Bros of New Romney, builders and builders' merchants in the 1900s and ran in conjunction with the builder's business they also established in Rye, (courtesy of John Bartholomew).

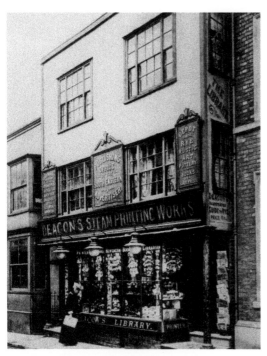

**Deacon's Library at No. 26 High Street, Rye, _c._ 1900s**
Another long-established business, serving a wide area, the library began in the eighteenth century as a printers, stationers and book sellers. The circulating library, a common combination with printing, charged 2_d_ per volume per week in 1898, or 1 guinea per annum with free loan of magazines. The business also dealt in artists' materials, postcards, pottery, sports equipment, musical instruments and sewing machines. It was a newspaper office and a publisher of a guide to Rye, as was a rival printer, Adams & Son, (courtesy of Frank Palmer).

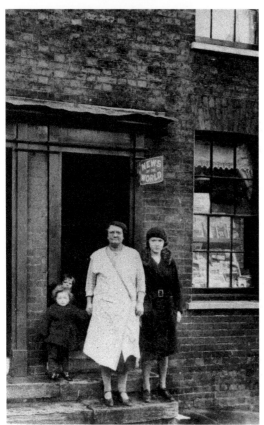

**The Start of a Small Business**
Mrs Jinny Rhodes at her newsagent's shop, opened in the front room at No. 3 Tower Street in the late 1920s. Mrs Rhodes, wife of Walter 'Jerry' Rhodes, a shrimper, built upon the example of her brothers who had carried on a newspaper delivery business in Rye from a handcart, (courtesy of Peter Ewart).

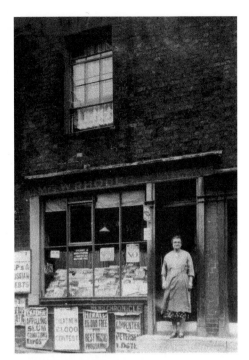

### The Business Expands
In a time of growing literacy and mass readership of newspapers, the business succeeded. After a few years, Mrs Rhodes moved to the adjoining No. 4 Tower Street, presumably to take advantage of the existing shopfront, (courtesy of Peter Ewart).

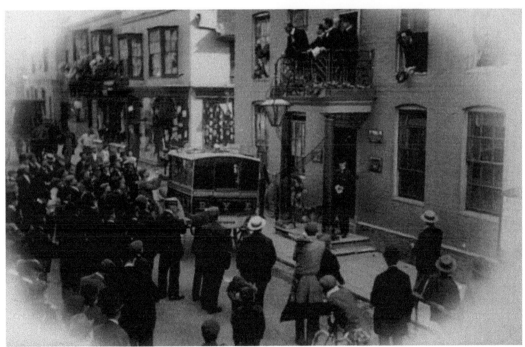

### A Public Speaker at the George Hotel, High Street, Rye, before 1899
The George was the leading hotel in Rye, used for many functions including civic dinners, auctions and meetings of all kinds. An assembly room was added in 1818 for dances and concerts. Bennett's horse-drawn omnibus travelled daily to Tenterden via the south-eastern railway station at Rye, (courtesy of Rye Museum).

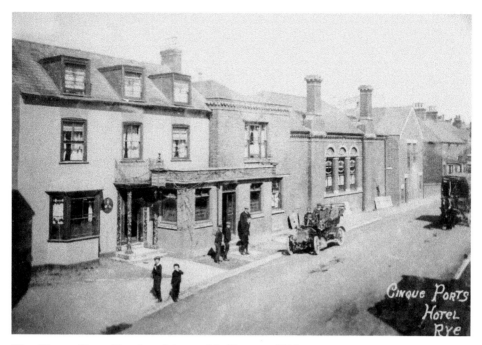

**The Cinque Ports Hotel and Assembly Rooms, 1910**
A coaching inn built in the early nineteenth century, the Cinque Ports was the meeting place of several organisations including sports clubs and the Rifle Volunteers. The adjoining assembly rooms were built in the 1860s and as the 'Bijou Theatre', were a popular venue for entertainments until 1931, (courtesy of John Bartholomew).

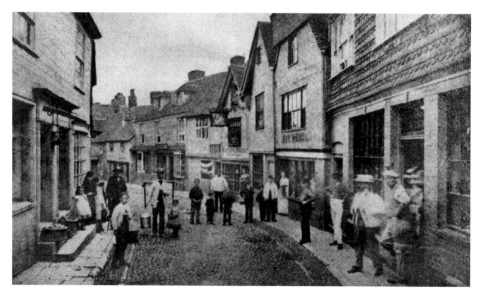

**The Mint, Rye,** *c.* **1870**
The photograph shows no fewer than three inns, with only one intervening building. The Foresters Arms, The Swan and The Standard, all opened in the mid-nineteenth century and were among twenty-one public houses recorded in the town in 1874. The number was reduced under legislation passed in the 1900s, (courtesy of Rye Museum).

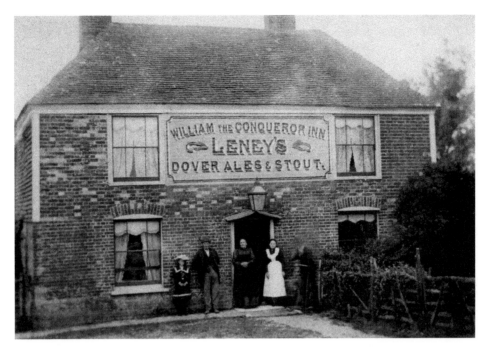

**A Country Inn**

The William The Conquerer in Iden, *c.* 1900. Most villages had two public houses, the landlords sometimes pursuing a second occupation such as saddler or carrier. The public house was a base for friendly societies in addition to being a venue for games and social life. The Dover Brewers, Leney & Co., bought Bowen's Eagle Brewery at Rye in 1900, (courtesy of Henry Dive).

## POSTAL SERVICES

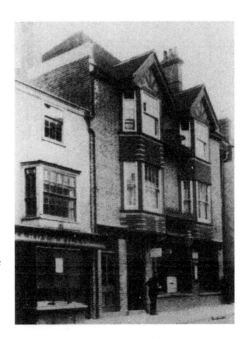

**Rye Post Office,** *c.* **1905**

Rye had the status of a head office with a money order facility, a savings bank and a telegraph office. The improved postal service and increased correspondence in the Victorian period led to several moves before a new office was built at Nos 18, 19 and 20 High Street in 1902. The post office moved to Cinque Ports Street in 1960 and is now located in Station Approach, (courtesy of Beryl Hutchings).

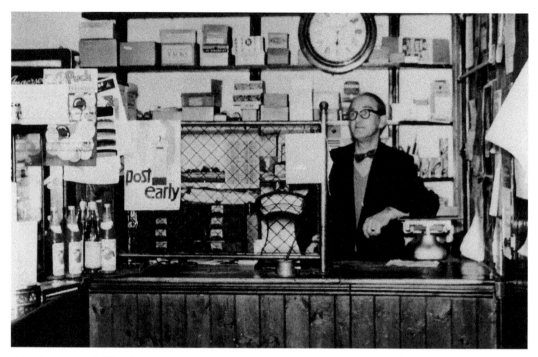

**A Village Post Office in the 1950s**
Arthur Wareham behind his counter at Peasmarsh Post Office and Stores, (courtesy of Dick Sellman).

**A Village Postman,** *c.* **1920s**
George Eldridge walked from Playden Post Office and delivered to East Guldeford and part of Playden. He is here seen outside Scots Float House, Military Road, Playden. His tunic was worn largely unbuttoned, displaying his waistcoat and watch chain.

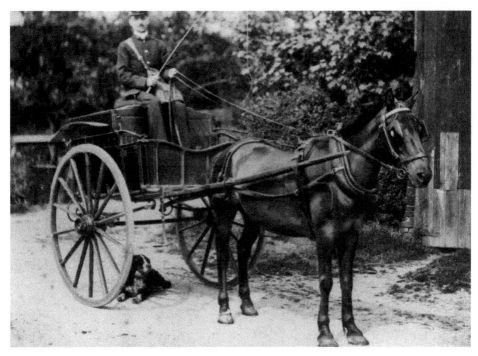

**A Horse-Drawn Mail Cart,** *c.* **1900s**

The cart carried mail from Rye Post Office to Northiam before the advent of motor vans. The dog probably accompanied the driver as a companion and guard dog. In the 1880s letters were taken on from Northiam to Brede every morning, (courtesy of Elizabeth Rigby).

## PROFESSIONAL SERVICES

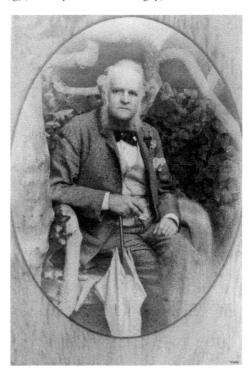

### Auctioneering

James Coleman-Vidler (1825–1898) took over the auctioneer's business run as a sideline by his father, John Vidler, a merchant at The Strand in Rye. He developed the business to include farm and trade valuations, house agency in Rye and Hastings and land agency for several rural estates. Elected Mayor of Rye on three occasions, his geniality and humour earned him the title of 'the most popular man in Rye', (courtesy of Rye Town Council).

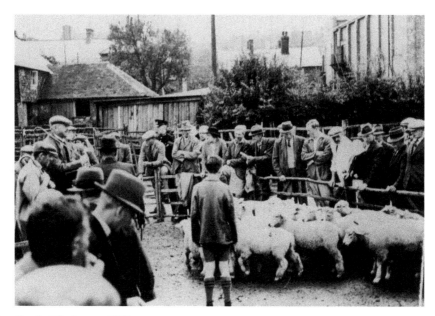

**Rye Cattle Market,** *c.* **1930s**
The market was established on its present site next to the railway in the 1850s. Normally a
fortnightly fat stock sale, the animals being sold for slaughter, the photograph shows an autumn
store sale of animals for further fattening. The auctioneer was Ernest Holden Stutely of Vidler
and Co. A policeman attended to prevent any cruelty to the animals by handlers, (courtesy of
Leslie Stutely).

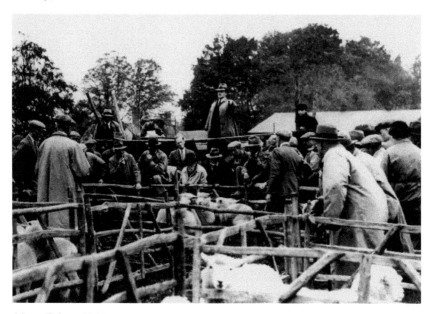

**Northiam Fair,** *c.* **1930s**
A twice-yearly store sale, the fair was started in 1901 by F. T. Lane Howse, a former schoolmaster
who had taken up farming and had responded to demand by farmers for a local market. A market
for regular sales was laid out near the railway station at Northiam and the business grew into the
estate agents' firm Howse & Co., with offices at Beckley.

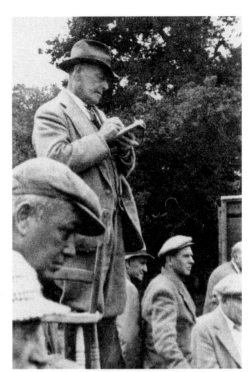

Lane Howse (1899–1965), son of its founder, took over Howse & Co. in 1932, acting as agent for the Brickwall Estate at Northiam and including timber valuation as a specialisation in the firm's business, (courtesy of Mary Howse).

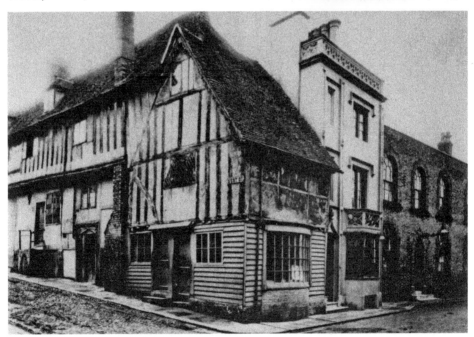

**The Rye Old Bank and Solicitor's Office, High Street,** *c.* **1890**
A bank was founded in Rye in 1790 by the solicitor and landowner Jeremiah Curteis, a partner in the firm of Curteis, Waterman & Woollett. The photograph shows the original bank on the right (then occupied by a later law firm) and Curteis, Pomfret and Co.'s Bank with ancient cottages adjoining to the left, (courtesy of Rye Museum).

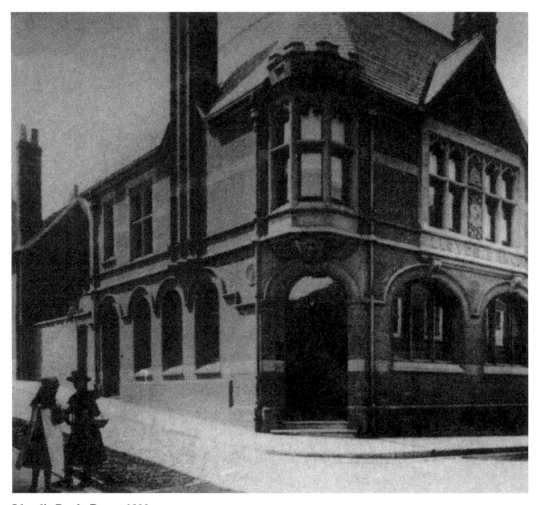

**Lloyd's Bank, Rye,** *c.* **1890s**
The Rye Old Bank was taken over by Lloyds in 1893, the cottages being demolished two years later to make way for a rebuilt and enlarged bank. This in turn was remodelled in 1920, (courtesy of Rye Museum).

# Section 5
# Public Life

In the nineteenth century Rye possessed its own Quarter Petty Sessions for the administration of justice, and a mayor and corporation for the government of the town. The latter enjoyed a long tradition, splendid ceremonies and regalia and were not averse to having their photographs taken! Both magistrates and councillors tended to be leading business and professional men in the town. In the rural area local landowners served as magistrates while the Poor Law Guardians and, after 1894, Rural District Councillors, were mainly farmers. Rye's position as a centre of local government was reinforced by the fact that all the various bodies met in the town or its outskirts and the part-time officers were professional men with local practices.

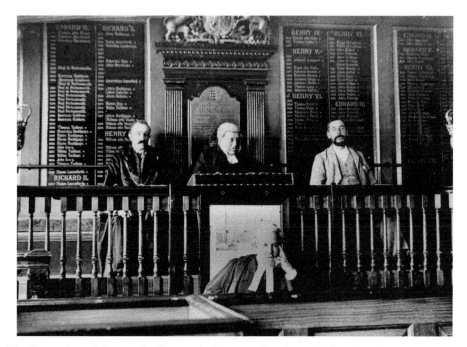

**The Recorder of Rye at the Borough Quarter Sessions, 22 October, 1900**
Rye Quarter Sessions were held at the town hall to try felonies under a barrister. The Recorder was R. H. Hurst, then aged eighty-three, sitting with two borough magistrates, the mayor, Frank Jarrett and Albert Edward Hinds. The clerk of the peace was a Rye solicitor, William Dawes, (courtesy of Rye Museum).

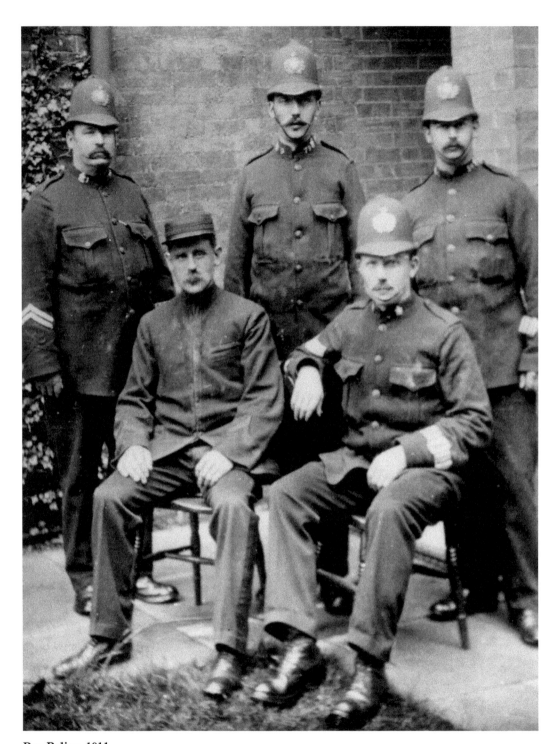

**Rye Police, 1911**
Standing, from left to right: PC Berry, PC Muggridge, PC Boniface (based at Playden). Seated: Superintendent Whitlock and Sergeant Sinclair. Rye Borough Police Force was taken over by East Sussex County Constabulary in 1889, (courtesy of Frank Palmer).

**A Parliamentary Election at Rye, 20 January, 1906**

The photograph shows the Liberal Committee Room at The Mint. The successful Conservative candidate was George Loyd Courthope who represented the division until 1934. Before 1885 when the constituency was enlarged, Rye had shared a borough member with seven adjoining parishes and, in the days of open voting, elections had been riotous occasions, (courtesy of Beryl Hutchings).

## BOROUGH CORPORATIONS

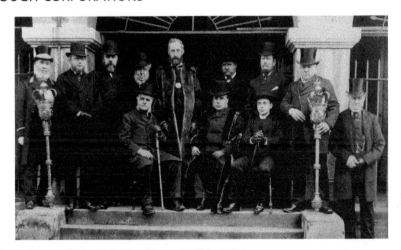

**Rye Town Council Outside the Town Hall in 1888**

Standing, from left to right: Edwin Hollis Pulford (sergeant at mace); John Neve Masters, watchmaker; Isaac Longley, grocer; John Holmes, retired shipbuilder; Herbert Verrall Chapman (mayor), brewer, John Amos Woodhams; surgeon, William Neeves, butcher, Isaac Wright; carrier and landlord of The Crown Inn; and William Boon, retired seedsman. Seated, from left to right: Alderman James Coleman Vidler; auctioneer, Kingsnorth Reeve (Deputy Mayor), auctioneer, and Revd A. J. W. Cross (chaplain), Vicar of Rye.

Three aldermen and three councillors were missing and a second mace bearer was either missing or not appointed at this period. The occasion was probably the election on 9 November 1888 when the new mayor and ex-mayor 'generously presented the town with a new scarlet cloth robe, trimmed with black velvet and musquash fur. It had long been known that Rye was entitled to robe her mayor in scarlet, and the old blue robe was handed down to the deputy mayor.' At this period, the Corporation dealt with public health and highways and provided the water supply, a fire brigade, street lighting and allotments. The mayor was ex-officio and a magistrate for the borough and, after 1894, for the Rural District Council area. The councillors were all business or professional men in the town, the first women being elected in the 1920s, (courtesy of Rye Museum).

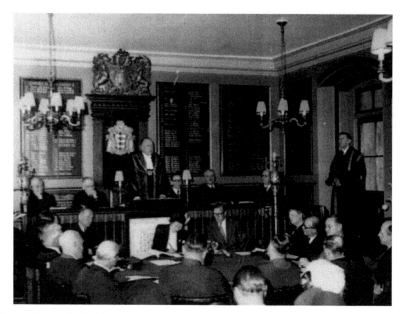

**Rye Town Council, 1954**

By this date, the council had acquired housing and planning functions and included members who had retired to the area. The mayor Maurice Beevers is on the aldermanic bench, and from left to right: Reginald Prebble, Harry Schofield, Henry Wood (town clerk), Brigadier-general Edward Wace, and David Candler. Below were the Medical Officer of Health and the Borough Surveyor, (courtesy of Rye Museum).

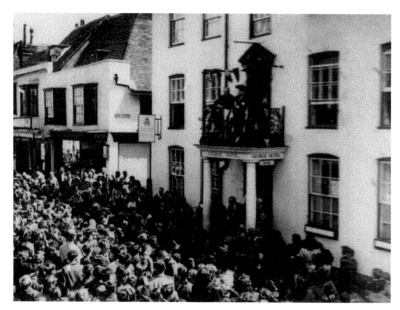

**Rye Mayor-Making Custom**

The mayor, Joseph Adams, throwing hot pennies to the children of Rye after his election in November 1911. The centre of the postcard concluded with a description of the venue: 'I guess you will see the balcony sticks out from the celebrated George Hotel where I shall most likely call in a very few minutes,' (courtesy of John Bartholomew).

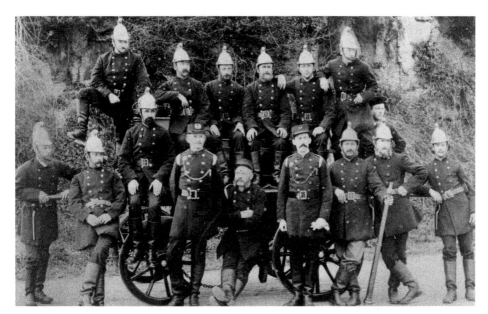

**Rye Borough Fire Brigade, 1890**
A volunteer brigade was formed in the 1860s and occupied part of the town hall until 1937. The trio in the centre were, from left to right, the captain, John William Eden, an insurance agent; the foreman Spencer Southerden, a painter; and the lieutenant, Cuthbert Hayles, a solicitor. The firemen's houses were all connected to a battery-powered electric alarm in 1894, (courtesy of Rye Museum).

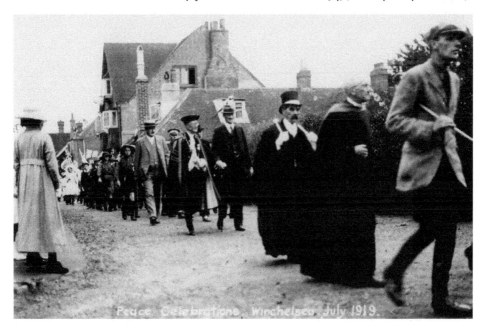

**Winchelsea Corporation**
Largely ceremonial after the 1880s, the Corporation is seen here in procession during peace celebrations in 1919. From right to left, excluding the first figure: Revd Robert Douglas (Rector), Jack Carey (Sergeant at Mace), Dr John Skinner, George Freeman KC (Mayor), Francis Tighe, John Malloch and Lewis Streeton, a boy scout, (courtesy of Winchelsea Corporation).

**The Boardroom at the Union Workhouse,** *c.* **1870**
This building at the summit of Rye Hill was the meeting place of the Poor Law Guardians, and after its formation in 1894, of the Rye Rural District Council, whose members also served as Guardians. Successor to the Rye Rural Sanitary Authority and to the Rye Highways Board, the council was known as 'the Farmers Club' because of the preponderance of farmers among its members. Anglican clergy, however, also took part, and two landowners, a grocer and a carrier were among the members in 1898. There was, for many years, one lady member of independent means, Miss Curteis, who was followed by her niece, Miss Burra. Apparently of a parsimonious nature, the council, of which no photograph survives, did not always see eye to eye with Rye Corporation, notably over joint repairs to Rye Harbour Road in the 1920s. The Sanitary Surveyor to the Council for many years was Edward John Cory, a partner in Reeve & Finn Auctioneers and Estate Agents, of Rye and Lydd, (courtesy of Frank Palmer).

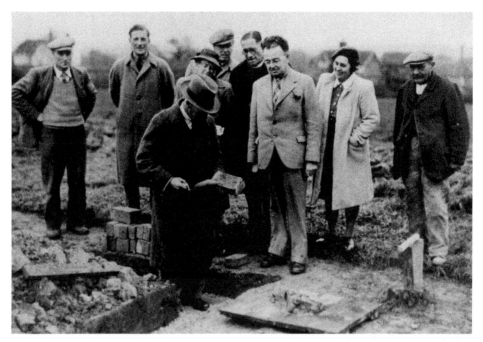

**Northiam Parish Council, 1946**
The chairman, Capt. A. R. J. Cyster, and members of the Parish Council laying the first bricks of twenty-four permanent council houses at Coplands Rise. The members include the rector, Revd O. E. J. Foster, and a contractor, W. E. Perigoe. In a time of post-war rebuilding, parish councils had been taking part in housing surveys, (courtesy of *Sussex Express*).

**County Councillor**
East Sussex County Council was formed in 1888, with responsibilities for main roads and the police and for education after 1902 and the poor law and all roads after 1929. Henry Curteis Burra (1870–1958) of Springfield, Rye Foreign, qualified as a barrister but, having inherited his father's estate, served as a magistrate and county councillor for Winchelsea. He was later an alderman and the chairman of the council.

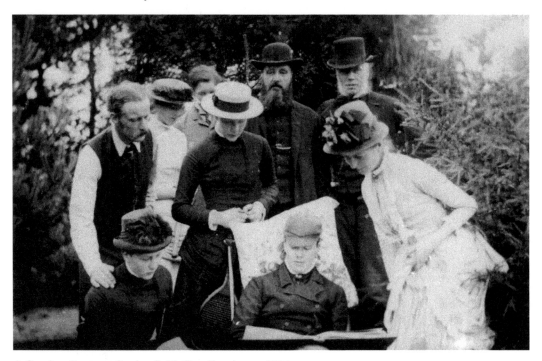

**A Garden Party at Springfield, Rye Foreign,** *c.* **1885**
From left to right: Henry Burra, Miss Mary Burra, Miss Ramus, Richard Burra, Miss Denise Burra, Bertie Ramus, Miss Frances Burra, Revd Charles Meade Ramus and Miss Ramus.

The parson and squire were influential in many villages. In addition to his economic power, the squire acted as magistrate in the rural area and often took an interest in social improvements. Henry Burra (1835–1886) was unusual in combining activities as squire of large estates in Sussex, Kent, Lincolnshire and Scotland with those of a banker and public figure in Rye. He won popularity as an impartial chairman, keen cricketer and Captain of the Rifle Volunteers, and served as a magistrate, town councillor and leader of the Conservative Party in Rye. In the words of a Rye historian, 'his purse and time had been at the service of every deserving cause'. The clergy were often men of distinction in secular fields. Charles Meade Ramus (1821–95), rector of Playden and East Guldeford, was also an inventor, interested in 'engines of warfare, particularly torpedoes' who worked on designs for a submarine and tested a prototype hydrofoil, 'the polysphenic ship', which by means of proposed inclines planes was to become the speediest in the world'. The 'ship' was stolen and burned by bonfire night revellers in Rye, (courtesy of Eleanor Brodrick).

**Revd George Augustus Lamb, D.D. (1781–1864)**
Rector of Iden, Playden and East Guldeford for fifty-seven years from 1807 to 1864, Revd Lamb was active in pre-reform politics in Rye, being the last Patron of the Borough, controlling elections for the government. An opponent described his 'superior intellect, capable of commanding the attachment of his partisans and of directing their energies to his views. His eloquence was not to be equalled in this locality.'

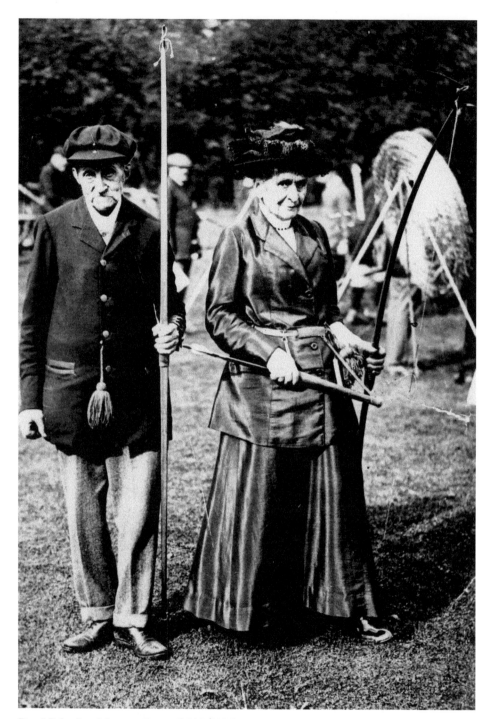

**Revd John Lockington Bates (1839–1923)**
Successor to Dr Lamb, Revd Bates was also rector of Iden for fifty-seven years. He was an international financier of 'remarkable and outstanding abilities', employing his son as curate while he spent time in the city and in America, where he financed railways. He and his wife were keen archers, founding a club at Iden Park called 'The Archers of the Ancient Towns'.

**Bell-Ringers at Iden Church,** *c.* **1900s**
From left to right: Fred Wells, Ted Coleman, Bill
Cloak, Ernie Briant, George Wood, Henry Dive,
Bill Wood and Billy Clark. The formidable figure
in the centre was Mr Bartholomew, presumably
captain of the ringers, (courtesy of Henry Dive).

**The Verger at Rye Church, 10 July 1913**
Charles Price was listed as verger from 1894 to
1924. Village churches invariably employed a
parish clerk or sexton to care for the church, dig
graves and assist at services, (courtesy of Beryl
Hutchings).

**A Three-Decker Pulpit at Playden Church, before 1898**
Dating from the eighteenth century, and associated with box pews and a western gallery, such fittings did not often survive Victorian church restoration. The pulpit was arranged on three levels. The clerk read the responses from the lower; the parson conducted the service from the middle and preached from the upper.

**Rye Baptist Church Opening Ceremony, 1910**
Long established in Rye, the Baptists moved from an eighteenth-century chapel in Mermaid Street to a new building in Cinque Ports Street. A notice refers to a public meeting and sermon by the Revd John Wilson, (courtesy of David Padgham).

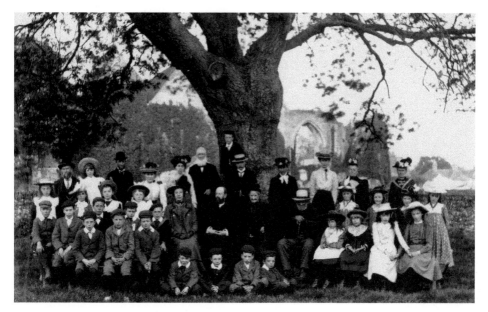

**The Bicentenary of John Wesley's Birth**
The celebrations at Winchelsea, Wednesday 24 June 1903, of the bicentenary of John Wesley's birth. Winchelsea Wesleyans were gathered under the ash tree under which John Wesley preached his last open-air sermon on 7 October 1790. Methodism was established early in Rye and Winchelsea and by 1903 there were Methodist chapels in every village, (courtesy of Hastings Museum).

## SCHOOLS

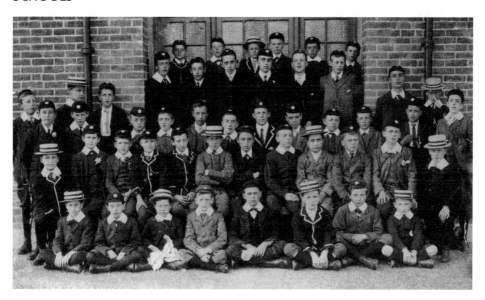

**Rye Grammar School Boys, 1908**
The school was an independent charitable foundation dating from 1638. Aided by the County Council, it moved from the original building in the High Street to new premises in The Grove in 1908, at the same time admitting girls for the first time. The later uniform of brown cap and brown blazer with blue trimmings appears to be represented among other clothing, (courtesy of Rye Library).

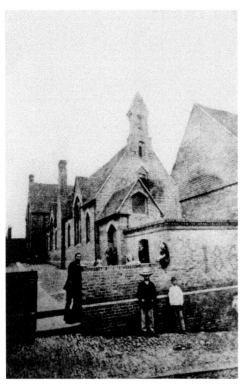

**Rye Boys Board School,** *c.* **1880**
The school was built as the Mermaid Street National School for 300 boys and girls by the Anglican Church in 1867. It was merged in 1876 with the Red Lion Board School in Lion Street, which had been built following the foundation of a school board to amend deficiencies in the voluntary system. The Lion Street School was attended by girls and infants, (courtesy of Frank Palmer).

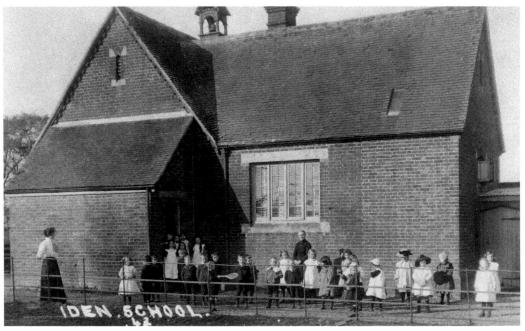

**Iden School,** *c.* **1917**
Built in 1868 as a national school for 106 children, the school closed in 1930 due to falling numbers. The school at Playden was selected to remain open as it took the children from the Rye Union Workhouse in Rye Foreign.

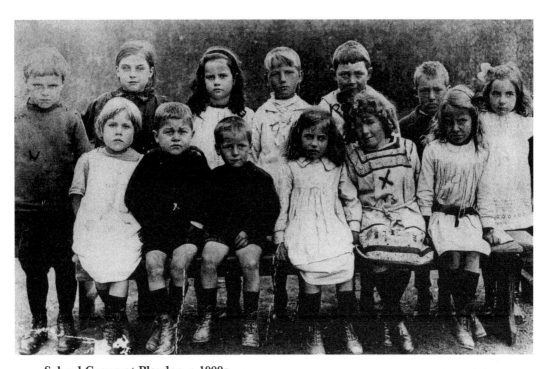

**School Group at Playden,** *c.* **1900s**
The workhouse boys may be recognised by their dark jerseys and, in one case, pugnacious expression,
(courtesy of Henry Dive).

# Section 6
# Domestic Life

The following photographs reveal a contrast between the leisured lifestyle of the wealthy, with staffs of servants and spacious homes, and that of cottagers struggling with well water and bundles of firewood. Housing included estate cottages and speculative terraces, while in towns and country ancient timber-framed houses were adapted for craftsmen and farm labourers. With the development of council housing from the 1920s, many old tenanted cottages in Rye and the surrounding rural area were sold to newcomers in search of something picturesque.

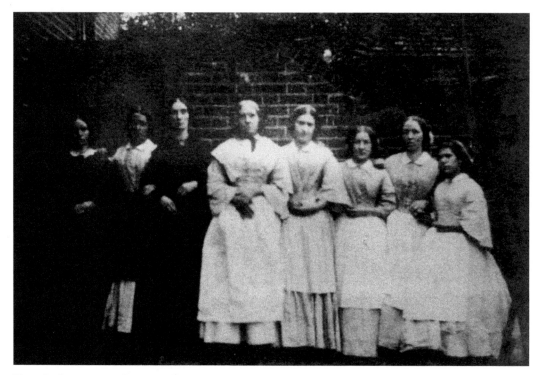

**Female Servants at Leasam House, Rye Foreign, 1860**
From left to right: C. Greenfield, A. Greenfield, S. Cheal, (lady's maid), Mrs Mantle (cook), L. Boots (housemaid), S. Colvin (housemaid), M. Ashdown, and A. Gasson. The servants formed a sizeable team at the home of landowner and farmer, Major Edward Barrett Curteis. Not included in the photograph was a butler, Stephen Care, who later married the lady's maid, Sarah Cheal.

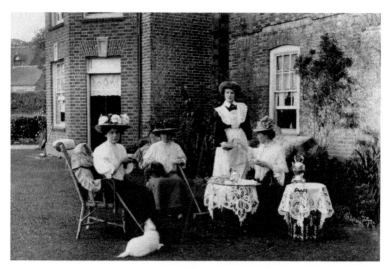

**A Croquet Party at Church House, Beckley,** *c.* **1990s**
A peaceful scene from the years before the First World War. Three fashionable ladies are seen being served tea and biscuits by a maid after a game of croquet on a country-house lawn. Everything indicates affluence and comfort: the lace tablecloths and inlaid table, an elegant kettle on a hot stand, lace window blinds, the ladies' hats, the maids' smart uniform and the immaculate garden. It has not been possible to identify the ladies, the house apparently having been let to a succession of female tenants, including, for a short period, the Misses Comforts' Collegiate School for Girls. Completed in the 1740s (with a later bay window on the left), the house was the home of the heiress Elizabeth Waters who shocked local society in the 1780s by marrying her young groom, Samuel Reeves. In the background is Beckley Church with dormer windows dating from the 1880s restoration, (courtesy of Mary Howse)

## COTTAGES IN TOWN AND COUNTRY

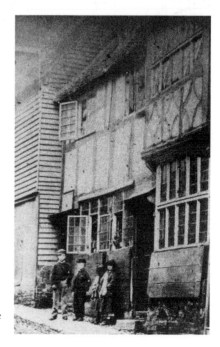

**A Timber-Framed House in Rye,** *c.* **1870**
Thomas House in West Street survived from the sixteenth century with little external alteration, retaining the elaborate projecting windows on the right. Many houses in Rye were affected by complicated subdivisions resulting in the flying freeholds which are still found today. These left the adjoining weatherboarded cottage bereft of even a yard. The notice related to Charles Thomas, a popular postman and Deputy Registrar of Births and Deaths who often read and wrote letters for the illiterate, (courtesy of Rye Museum).

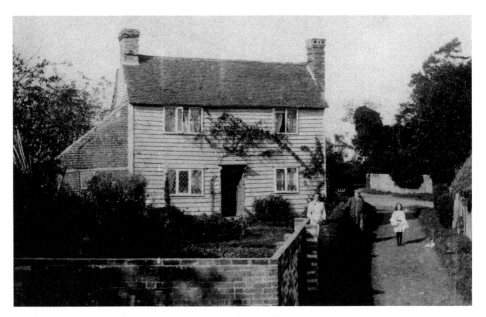

**A Weatherboarded Cottage at Peasmarsh,** *c.* **1910**
Typical of many eighteenth-century cottages in the country, this one had a central doorway with
a kitchen on the left (with a larger chimney) and parlour or scullery on the right, often with a
lean-to at the rear. It stood in a group of 'wayside' cottages, built on the wide road verges at
Flackley Ash Hill, including, on the right, a large encroachment within the road itself, (courtesy
of Peasmarsh WI).

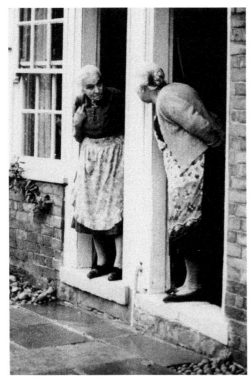

**Neighbours in the Town**
Two old ladies exchanging gossip on their
doorsteps on the west side of Church
Square, Rye, in the 1950s, (courtesy of Rye
Museum).

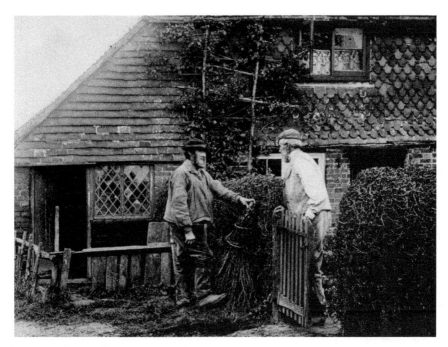

**Neighbours in the Country**

Two old men talking over the garden gate in the 1890s. Note the short smock, trousers tied at the knee, and besom broom, which was placed over a stake and used as a boot brush. The cottages have only recently been identified as the Old Workhouse, Guestling, just outside the former Rye Rural District, (courtesy of Hastings Museum).

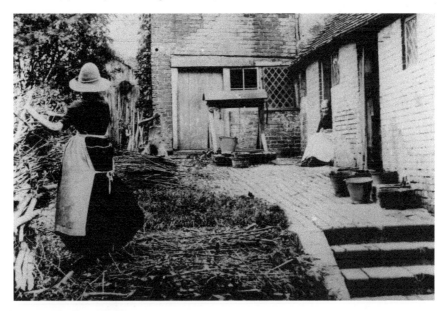

**A Cottage Yard, *c.* 1890s**

An interesting study of domestic arrangements in a cottage yard in the 1890s. The well required turning by hand, and the firewood had to be bundled into faggots or chopped on the block in the background, (courtesy of Hastings Library, Ray Collection).

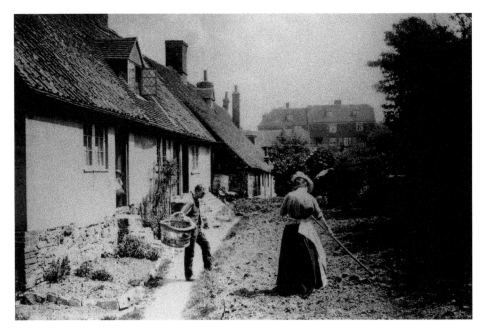

**A Cottage Garden,** *c.* **1890s**

A mother is seen hoeing a small garden put to use as a vegetable plot, watched by a child in the doorway and by the baker's delivery boy. The photograph also shows the back of cottages at North Street, Winchelsea, with The Five Houses, School Hill, in the background, (courtesy of Hastings Museum).

**Brede Place,** *c.* **1890s**

Built around 1400 by the Oxenbridge family and later extended by them, the estate was own in the seventeenth and eighteenth centuries by the Frewens of Brickwall, Northiam. The house was occupied by yeoman farmers, bailiffs and farm labourers. Partly restored in 1872, it was not permanently occupied until the 1913/14 when Moreton Frewen employed the architect Lutyens to complete the work. The house was gutted by fire in 1979, (courtesy of Hastings Museum).

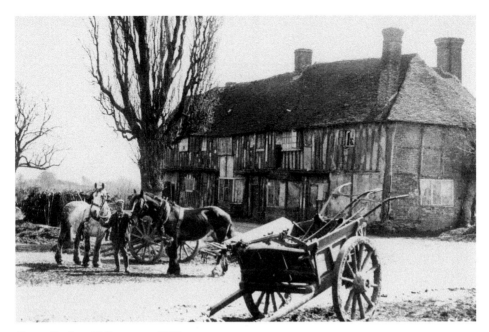

**Court Lodge, Udimore,** *c.* **1910**
Another gentry house, Court Lodge, has been a secondary home of the Etchingham family since the Conquest. The house was rebuilt after 1479 and, owned by non-residents, the surviving north range was used from 1690 as farm labourers' cottages. These were dismantled and moved to a new site at Groombridge in 1912, (courtesy of David Padgham).

**An Occupant of Court Lodge, Udimore,** *c.* **1890s**
At this period, Court Lodge was occupied by James Cooper, farm bailiff to Robert Kenwood of The Hammonds, Udimore, and by four farm labourers and their families. This splendid portrait by George Woods shows an old man carrying a billy can and stick and dressed in a long smock, wide felt hat and gaiters – probably the all-weather clothing of a shepherd rather than a bailiff, (courtesy of Hastings Museum).

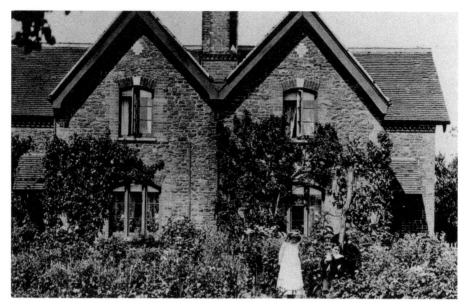

**Winton's Cottages, Peasmarsh,** *c.* **1913**
These estate cottages on the Peasmarsh Place Estate of Charles Lyon Liddell were built around 1906, together with a nearby house in a similar style for the estate bailiff, both using sandstone quarried on the estate. Each cottage contained three bedrooms, a parlour, a kitchen, a pantry and a scullery, (courtesy of Doug Smith).

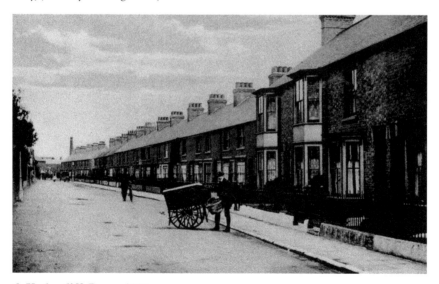

**South Undercliff, Rye,** *c.* **1910**
Rye was increasingly developed by speculative housebuilders from the early nineteenth century. South Undercliff was built in phases: Gordon Villas on the right in the 1880s, Castle Terrace beyond in 1904/1905, and Battery Gardens after 1907. The houses were decried as an eyesore, although 'much needed'. Note F. J. Thompson's baker's handcart and the chimney of the Rother Ironworks, (courtesy of John Bartholomew).

# Section 7

# Rye at Play

Rye's active social life is revealed in both the photographs and in local directories. The town possessed at least thirty-six leisure organisations in 1898, covering sporting, educational, dramatic, musical and religious interests. The villagers were equally adept at home-grown entertainment, even the smallest having a cricket or a football club and many boasting a village band.

Although some activities, notably golf, were based on social position, many provided an opportunity for both rich and poor, including field sports, annual events and organisations such as the Boy' Scouts and the Women's Institute. The countryside provided activities for all, including visitors, and was often reached by the railway.

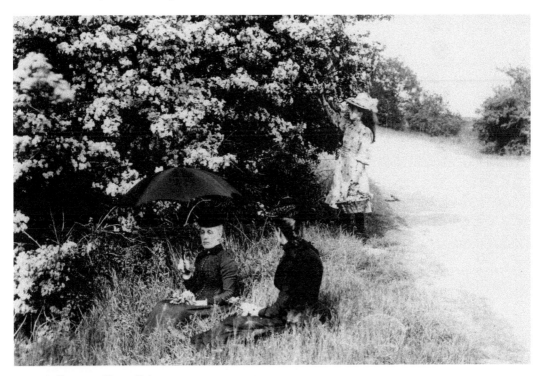

**A Country Expedition**
Gathering May blossom at Winchelsea in the peaceful countryside of the 1890s, probably on the Royal Military Road to Rye. The older lady carried protection against the sun, (courtesy of Hastings Museum).

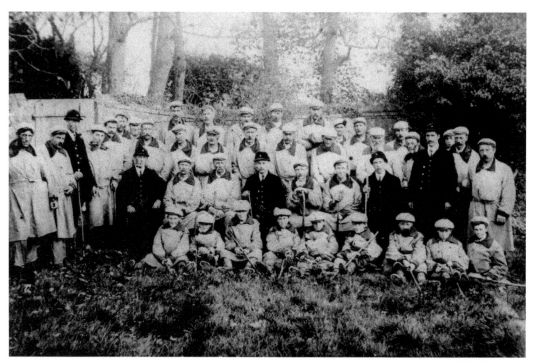

**A Group of Gamekeepers and Beaters on the Fairlight Hall Estate, late nineteenth century**
An impressive turnout of no less than five keepers, twenty-nine men and nine boys, all provided with
livery. At its peak the estate included almost all the land in Fairlight and Pett, with part of Icklesham as
far as Rye Harbour. It was founded by William Lucas Shadwell, a Hastings solicitor who is said to have
made a fortune from building Martello Towers for the government in the Napoleonic Wars. His son
built a castellated mansion at Fairlight, from which his wife exercised her care over the estate, building
churches and reading rooms, and closing public houses (her young brother had died in a runaway
carriage neglected by a groom drinking at an inn). The estate, already reduced in size, was split up and
sold in 1917, partly for the residential development now at Pett Level and Fairlight Cove, (courtesy of
Anne Scott).

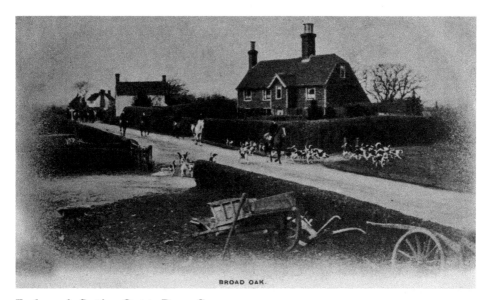

BROAD OAK.

**Foxhounds Setting Out to Draw Cover**

Foxhounds setting out to draw cover from a meet at the Broad Oak Inn, Brede, from a postcard sent in 1903. Note the broken farm implements in the foreground, possibly awaiting repair at the nearby wheelwright's shop, (courtesy of David Padgham).

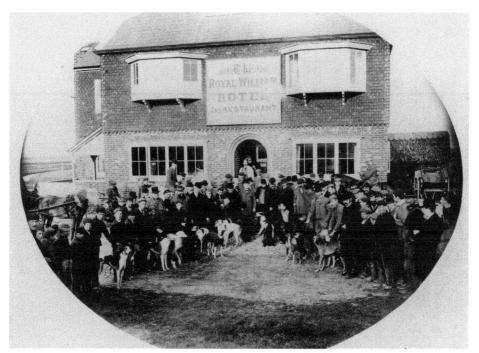

**Hare-Coursing at Camber, *c.* 1900s**

A popular sport, here represented by the Rye and East Guldeford Coursing Club at its regular venue, the Royal William Hotel. Coursing involved releasing a captive hare for chasing over short distances by greyhounds, in contrast to beagling, where the hunt was a much longer process. Many hares escaped from the hounds, (courtesy of Rye Museum).

**A Rye Football Team,** *c.* **1910**

Apart from Frank Barling, standing fifth from the left, the team has not been identified. The players appear to be wearing the red-and-black shirts of the Rye Town Club, and initials possibly referring to the second XI. Other clubs of the period were Rye Albion, Rother Invicta and St Mary's, (courtesy of Rye Library).

**A Cricket Team at the Salts, Rye**

Dressed in the clothes of a previous age, the team may have been an earlier version of the 'Old English Cricketers' Mr T. Sharpe's XI who were photographed at the coronation celebrations in 1911. The elegant figure on the left appears to be T. Sharpe, next to H. J. Gasson, but most of the players are different to those known to have been present in 1911, (courtesy of Rye Library).

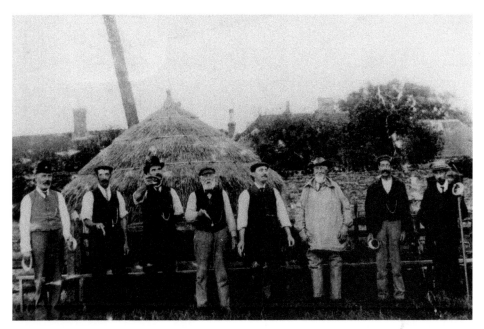

**Winchelsea Quoits Team,** *c.* **1900**
Pictured at the present cricket field, the team included a roadman 'Chummy' Barden (left), a plumber, Ernest Freeman and a shepherd, Bill Eldridge (the latter two flanking the smocked figure). Quoits was also played among fishermen in Rye, where a four-gallon jar of beer was 'deemed essential for keeping the players eye in', (courtesy of Winchelsea Corporation).

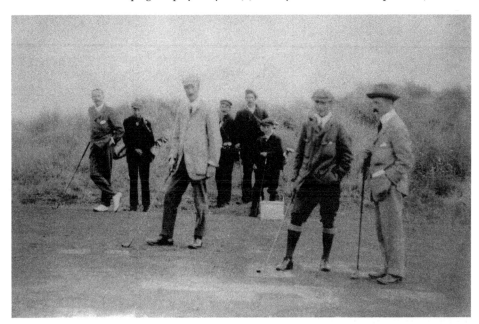

**Golfers and Caddies at Rye Golf Club,** *c.* **1900s**
A game for the elite, the Rye Club numbered a future king (George VI) and prime minister (A. J. Balfour) among its visiting players. Social distinction is evident from the debonair poses of the players contrasting with the rather uncertain demeanour of the caddies.

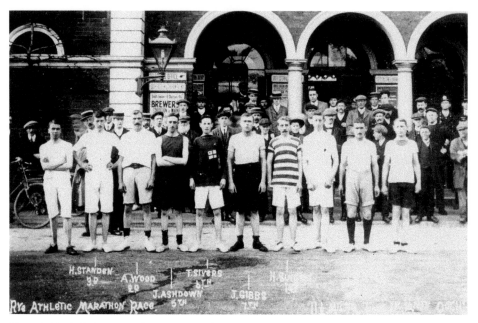

**'Rye Athletic Marathon Race, 11½ Miles, Time 1h 10 mts, Oct 11th 1910'**
A regular annual event from the 1900s, photographed over here at the railway station or at the Town Hall. A. Wood, here in second place, was a frequent winner, (courtesy of John Bartolomew).

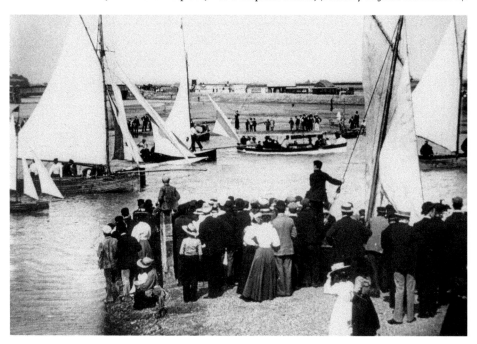

**Rye Regatta,** *c.* **1900**
Associated with an annual Sports Day on The Salts, the Regatta was revived in 1888. The boats included sailing yachts and a steam launch, with the Monkbretton Bridge and the Camber tram in the background. Events included races of various kinds, water polo, decorated boats and the slippery pole contest on the bowsprit of a fishing boat, (courtesy of Basil Jones).

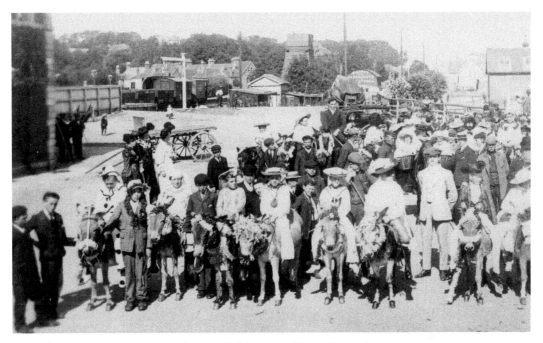

**Treat to the Children of Rye by H. J. Gasson, Esq. Mayor, 1905**
Such treats were a regular feature of the mayoral year in the 1900s and included events on The Salts.
Taken at the station approach, the photograph shows garlanded donkeys and children in fancy dress, with
a goods train, railway water tower and the cattle market in the background, (courtesy of Rye Museum).

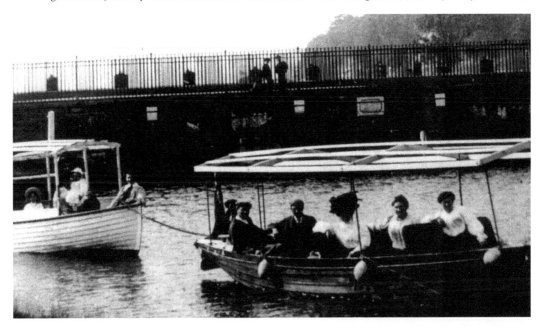

**Pleasure Boats on the Rother,** *c.* 1910
Later operated with a tearoom, the boats offered return trips from Scots Float Sluice, Playden (in
the background) to Bodiam Castle. They were popular among visitors and among shop assistants on
early-closing afternoons.

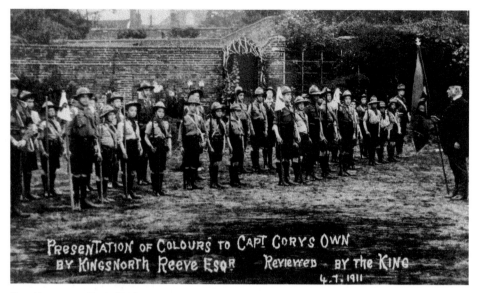

PRESENTATION OF COLOURS TO CAPT CORYS OWN
BY KINGSNORTH Reeve Esqr     Reviewed BY THE KING
4.7.1911

**Boy Scouts at Rye, 1911**
Founded in 1909, the first Boy Scouts troop in Rye was led by Capt. Edward John Cory, a Boer
War comrade of Baden-Powell and partner in the auctioneering firm Reeve & Finn. The troop
was revived by the King at a national rally and, Capt. Cory having died in March 1911, the
colours were presented by his uncle and business partner, Kingsnorth Reeve.

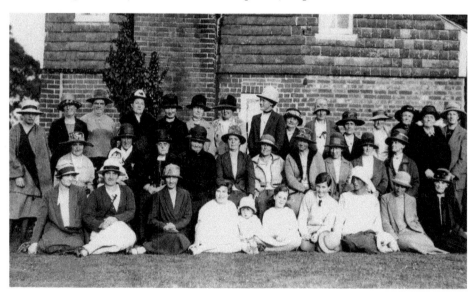

**Iden Women's Institute, c. 1925**
The Iden WI was founded in 1918, as were many others in the district. Outdoor meetings were
held in the summer, in this case at Miss Foster's, now Hedgerows, Grove Lane. Miss Foster is
seated in the middle row, fourth from the right, next to the President, Dorothy Carter (fifth). Also
included are Gertrude Coleman (front left) and Mrs Chittenden (standing, second from right),
(courtesy of Ernie Burt).

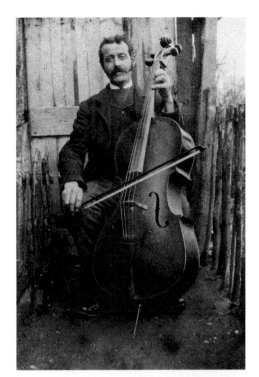

**Cello Player,** *c.* **1900s**
Jim Coleman, of Military Road, Playden, with
his cello, at Bosney Farm, Iden, in the 1900s.
The Coleman brothers, including the farm bailiff
Richard Coleman, would meet at the farm on
Sunday afternoons for music sessions. A string
band played at Iden in this period under the
leadership of the grocer and butcher, Pierce Pettitt,
who also advertised stringed instruments under
the striking headline 'Violins! Violins! Violins!',
(courtesy of Gurtrude Coleman).

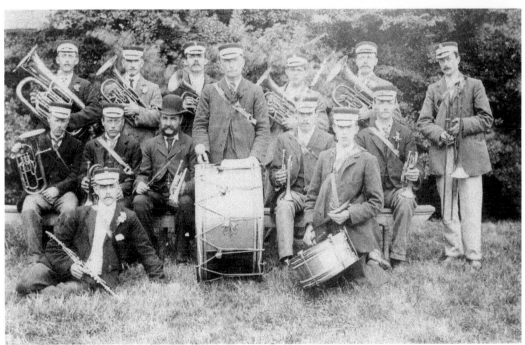

**Peasmarsh Brass Band, 1900s**
Founded in 1902, the band went to many engagements outside Peasmarsh and were taken to them by the
village carrier, Ernest Offen. They practised in an oast house, moving to a stable at The Cock Inn when the
oast house was required for drying hops, (courtesy of Rye Library).

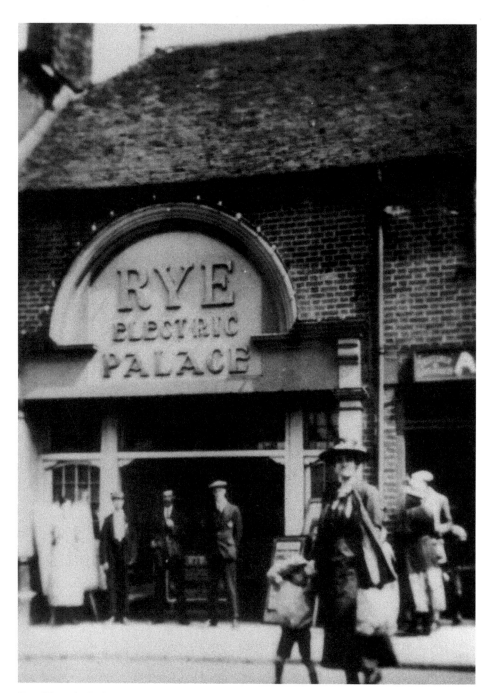

**Rye Electric Palace,** *c.* 1920

Regular mass entertainment began in Rye when its first cinema opened at the Landgate in 1912, starting with a hand-cranked projector and soon showing recruitment films for the First World War. The building had its own generator (before the introduction of mains electricity to Rye in 1925) to power its lights, including the bulbs forming the lettering over the door. The Electric Palace closed in 1932 when the owners built the first Regent Cinema in Rye, (courtesy of Rye Museum, Band Collection).

# Section 8

# Transport

The importance of water, both sea and navigable river, as a means of transport, has already been seen. The link between the port and town and their market areas was the road system, still under the control of turnpike trusts and parishes at the start of the photographic period. The railway took some goods away from both the ports and roads from 1851 but opened the town to new influences and business interests and later provided a stimulus to tourism. Local journeys were made by horse-drawn vehicle, represented in the photographs by local carriers and farm wagons, as well as by private transport among the better off, and commercial vehicles were used for excursions from an early date.

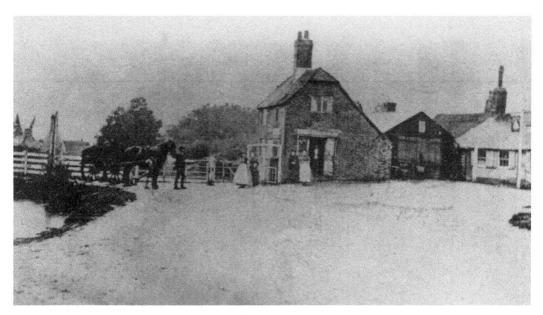

**Playden Tollgate at the Peace and Plenty, 1872**
A turnpike trust took over the main London Road between Rye and Flimwell in 1762 but, in common with others, suffered from railway competition and was wound up in 1872. The cart from the adjoining farm was the last vehicle to pass through the gate. The public house started as a beer shop in the 1860s and was largely rebuilt in 1903, (courtesy of Henry Dive).

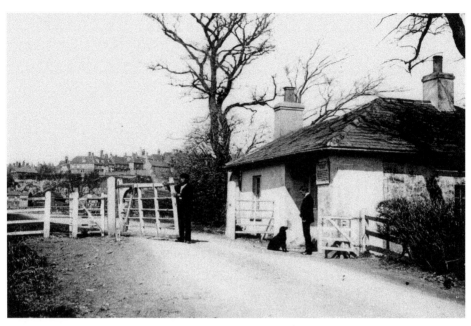

**The Winchelsea Road Tollgate,** *c.* **1890s**
Built by the military authorities on a new route to Winchelsea in conjunction with the Royal
Military Canal, the road was completed around 1808 and remained in military hands until 1926.
The gate stood at the junction with Rye Harbour Road, (courtesy of Hastings Museum).

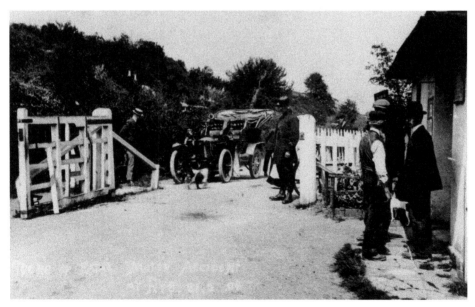

**A Fatal Motor Accident at the Military Road Tollgate, Playden, 27 May 1908**
Also part of the Royal Military Canal between Pett and Hythe, the road from Rye to Appledore
retained a tollgate long after their removal from other roads. The gatekeeper's wife, Mrs Thomas,
was hit by the car while opening the gate, (courtesy of Henry Dive).

**A Lane at Winchelsea,** *c.* **1890s**
Minor roads were maintained by the parishes and the Highway Board until the Rye Rural District Council took over the responsibility in 1894. 'Lengthsmen' were employed to maintain a few miles of road each. Overhanging branches were the responsibility of adjoining owners and in 1879 a member of the Highway Board complained that 'at one part of Northiam [he] could hardly drive along beneath the trees without having [his] hat knocked off', (courtesy of Hastings Museum).

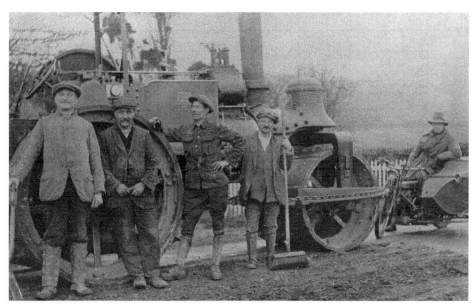

**Road Mending at Peasmarsh,** *c.* **1920s**
The contractors, possibly assisted by council lengthsmen, were Reeve & Selmes of Rye, who also undertook steam-haulage, threshing and ploughing. A foreman or inspector had arrived by motorcycle. Note the ex-First World War army uniform, (courtesy of Dick Sellman).

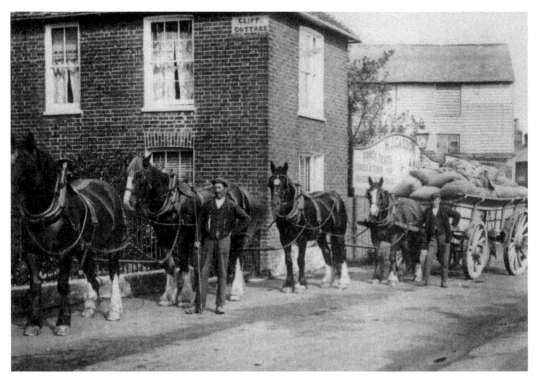

**Farm Wagon at Rye,** *c.* **1910**
Two carters from Oxenbridge Farm, Iden, pictured at Fishmarket Road, probably on their way to
Stonhams Warehouse at The Strand with a load of grain, avoiding the busier Cinque Ports Street.
This area, on the outskirts of Rye, was then recently developed when, in 1859, Cliff Cottage was
occupied by Edward Bayley, a master mariner, and the cottages on the right by Jesse Lee and his
tenants. The warehouse was built after 1907 on the site of Taverners Wool Warehouse and Tanyard.
The advertisement hoarding relates to H. J. Gasson's 'fancy tents and marquees, garden and tennis
bordering nets', part of a diverse business built on government surplus goods and the manufacture in
Rye of tarpaulins and nets, (courtesy of Bert Vidler).

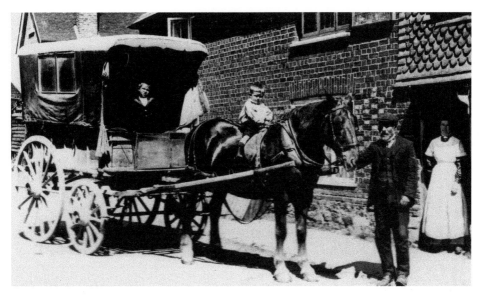

**A Winchelsea Carrier, in 1911**

Lewis Streeton was one of three carriers who ran a daily service to Rye; one of the others also travelled to Hastings on three days in the week. Streeton was a publican as well as a carrier, a common combination and is here pictured outside his Salutation Inn in Mill Road with members of his family, (courtesy of Eric Streeton).

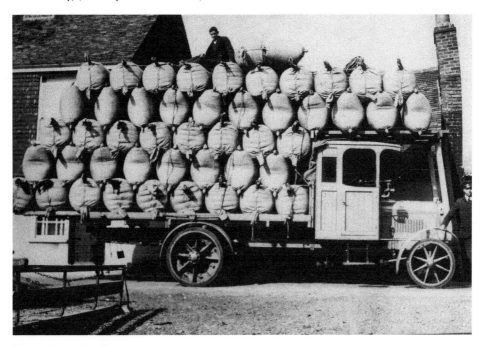

**Motor Lorry at Rye**

John Jempson (right) founded a motor-haulage firm in Rye in 1924, having worked in his father's horse-haulage business. The photograph shows hops on a J-Type Thorneycroft lorry, bought in 1926, in front of a family home, Ebenezer Cottage, at the firm's yard at The Strand, (courtesy of Frank Palmer).

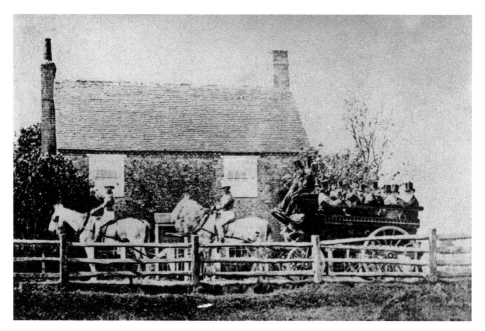

**Driving Out in Style in the Rye Area,** *c.* **1860**
A party of well-dressed excursionists in a hired wagonette controlled by two post-boys, each riding a horse and wearing the white 'Miller' hat, short jacket and steel boots left over from the coaching era. The wagonette was an open carriage with one or two crosswise seats in front and two inward-facing seats behind, (courtesy of Eric Offen).

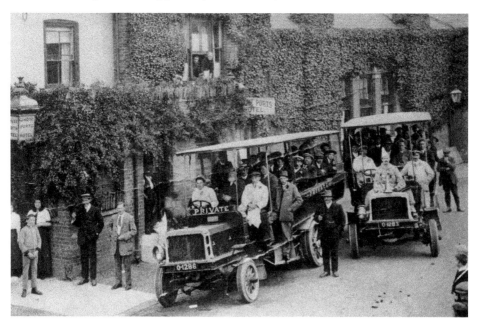

**A Works Outing,** *c.* **1910s**
Motor charabancs outside the Cinque Ports Hotel during a visit to Rye by employees of the East Kent Brewery. Horse-drawn passenger vehicles were earlier victims to motor competition than their freight counterparts, (courtesy of Rye Library).

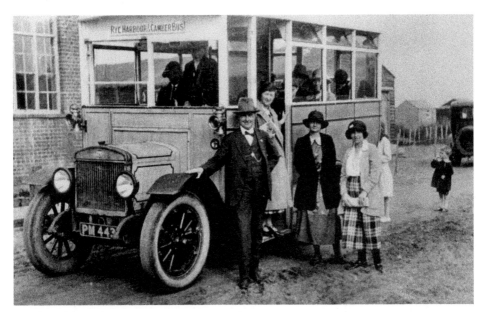

**The Rye Harbour and Camber Bus,** *c.* **1920s**
Pictured at the rebuilt Royal William at Camber, the service was run six times a day and at weekends by Wright and Pankhurst, also haulage and removal contractors and taxi operators. The firm's buses were decorated with local scenes painted on the rear. In 1930 the firm sold their bus routes to the East Kent Road Car Company, (courtesy of Rye Museum).

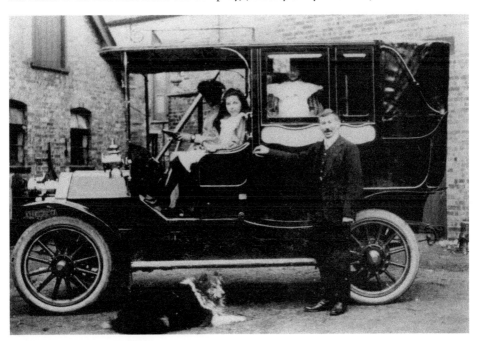

**A Rye Motor Taxi,** *c.* **1910s**
The taxi was run by Wright & Pankhurst from the yard at their 'Fireproof Furniture Repository' in Tower Street, Rye, built in 1907. The firm was described as motor-car proprietors from 1911 and later operated 'first class motors for hire', (courtesy of Rye Museum).

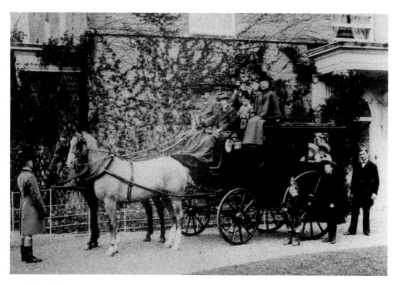

**A Private Omnibus at Leasam House, Rye Foreign**
A private omnibus during the occupation of the Leasam House from 1885 to 1903 by Col Arthur M. Brookfield, MP for Rye. This vehicle was often used in country houses to transport visitors and luggage from the railway station, in a period of nostalgia for the coaching past. The driver was Capt. Cruickshank, apparently a guest at the house. The house had been built in around 1800 by Jeremiah Curteis (solicitor, town clerk and founder of the Rye Bank) for the occupation of his daughter Anne and her husband Samuel Russell Collett. Sold to Brookfield in 1885, it was extended and refaced in 1903 by the subsequent owners, Admiral Sir George and Lady Maud Warrender.

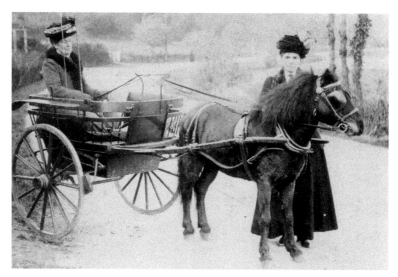

**A Farmer's Wife on Her Way to Rye, *c.* 1900s**
Mary Ann Chittenden, wife of George Chittenden of Boonshill Farm, Iden, and her sister Rachel, pausing for the photographer at Military Road, Playden, in a governess cart which had a rear door and steps suitable for children. These vehicles remained popular until the 1930s, (courtesy of Iris Maxfield).

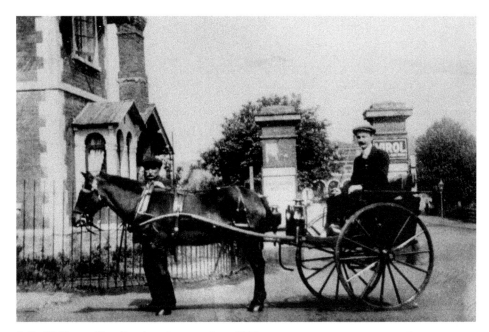

**A Ralli Car at Rye Station Approach,** *c.* **1910**
Popular in rural areas until the Second World War, and probably made by local wheelwright, the
Ralli car was a compact variation of the dog cart, with space for one or two people and luggage.
The photograph shows the arched front of the station and on the left the station lodge, later
W. T. Smith's auctioneer's offices, (courtesy of Rye Museum, Band Collection).

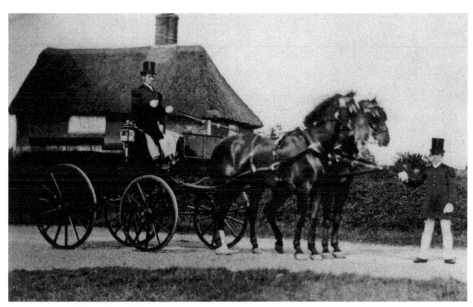

**A Private Wagonette at Iden,** *c.* **1880**
The vehicle belonged to the Curteis family of Leasam House. Presumably used for picnics and
outings, the passengers may have stopped for refreshment at William the Conqueror, behind the
photographer. The house in the background, Partridge, has changed little since the picture was
taken. Note the coachman and groom in livery with epaulets.

**The Dawn of the Private Motor Car**
Real affluence displayed in the 1990s at Brickwall, Northiam, home of Edward Frewen, landowner and lieutenant colonel in the East Kent Imperial Yeomanry (volunteer cavalry). Unfortunately, none of the people can be identified. The façade of the house was completed in 1633 by the White family, predecessors of the Frewens, (courtesy of Mary Parsons).

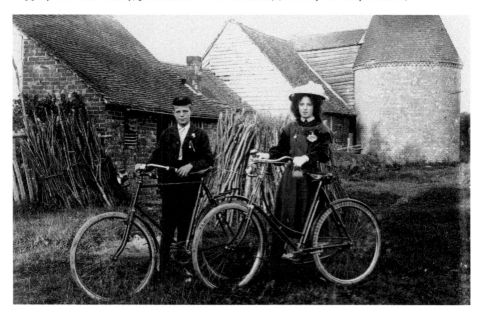

**Children with Bicycles,** *c.* **1900s**
This charming photograph was found in a collection of glass negatives at Beckley. The girl, in particular, is well dressed, wearing jewellery and gloves and carrying a tiny handbag or purse. Although not used after 1908, the letters 'R. S.' on the boy's cap may denote Rye Grammar School. The oast house at Brickfield Cottages, Beckley, has one roundel added to an earlier building, (courtesy of Mary Howse).

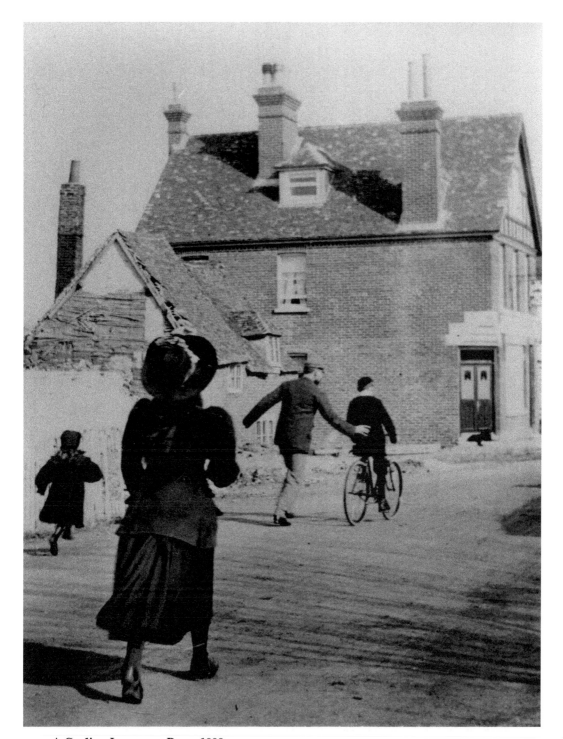

**A Cycling Lesson at Rye** *c.* **1900s**
The 1900s were a period of change in Ferry Road. The Ferry Boat had recently been rebuilt as The New Inn, and houses had been demolished next to the cottages on the left, themselves pulled down soon after. By 1907 a terrace of houses had been built on the two sites, (courtesy of Rye Museum).

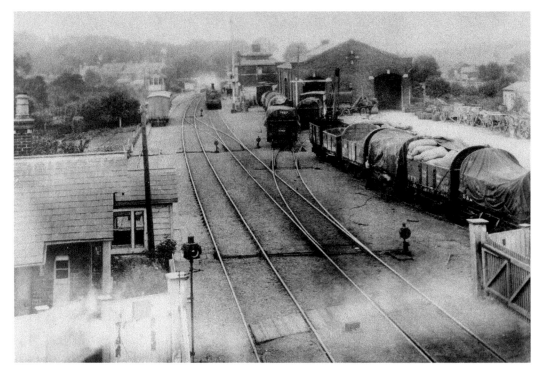

**Rye Railway Station and Goods Yard,** *c.* **1890s**

Opened in 1851, the station was on the South Eastern Railway Company's line from Hastings to Ashford. Taken from the footbridge at the Ferry Road crossing, this fascinating photograph shows busy sidings, with trucks (one apparently loaded with hops) being covered with tarpaulins, a crane and a motley collection of empty farm wagons on the right. A horse and van can be seen waiting in front of the goods shed, beside which a siding led via a turntable to the wholesale grocery warehouse, Hicks & Sons, in Cinque Ports Street.

In the background, figures are visible standing on the platform beside a steam train about to pull away on the downline to Hastings. The signalling arrangements at this period included a tall signal post and signal box near the station, various shunting lights between the tracks and a signal box adjoining the lodge.

The picture can be dated to after 1893 by the signal box opposite the station and, unless the railway company was slow to the change the lettering on the trucks, to before the merger which formed the South Eastern and Chatham railway in 1899. A gatehouse had been built next to the gate on the right by 1907, (courtesy of Rye Museum).

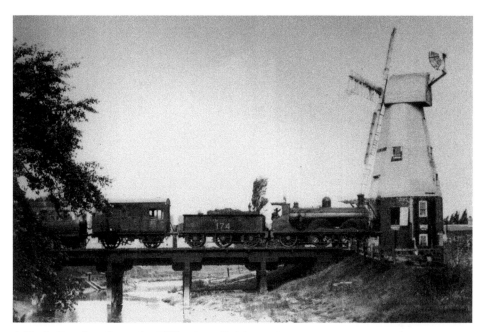

**A Train Passing Over the Tillingham Bridge,** *c.* **1920s**

A train passing over the Tillingham Bridge following the merger which formed the Southern Railway in 1921. The 0-4-2 engine (no bogey, four driving and two trailing wheels) draws a tender, horsebox and passenger coach over the wooden trestle bridge replaced in the 1950s. The windmill burnt down in 1930 and, although redundant, was rebuilt as a shell to comply with the terms of the lease, (courtesy of Rye Museum).

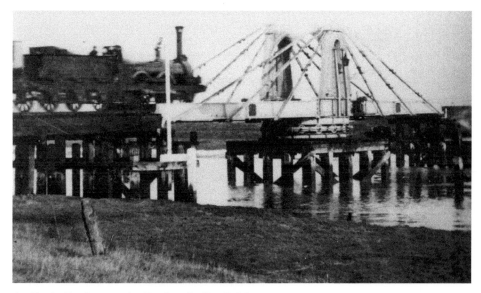

**An Early Engine on the Rother Swing Bridge**

Built to enable boats with fixed masts to travel along the river, the bridge was replaced in 1903 to allow full conversion to a double track. The 2-4-0 engine is very similar to that shown on an engraving of the bridge in 1851. Lacking cab protection for the driver and fireman, such engines went out of use around 1870, (courtesy of Rye Museum).

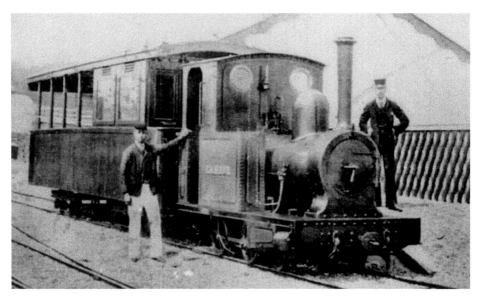

**The Rye & Camber Tram**

Remembered with affection by many, the 3-foot gauge tramway was opened in 1895 to serve fishermen and members of the newly opened Rye Golf Club. Later extended to Camber Sands, the line was crowded in summer with day-trippers. The photograph shows a trial run of the first rolling stock, the 2-4-0 tank locomotive *Camber* and a single carriage, at the Rye terminus. Requisitioned in 1939, the tramway was closed after the war, (courtesy of Hastings Library)

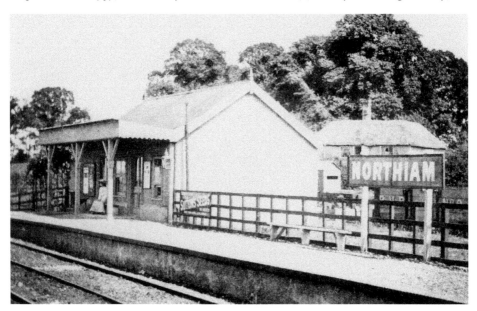

**Northiam Station**

Designed by Holman Stephens, also engineer to the Rye & Camber Tramway, the Rother Valley Railway was opened in 1900 between Robertsbridge and Tenterden (later extended to Headcorn). The rolling stock behind the platform indicates a date before the renaming of the line as the Kent and East Sussex railway in 1904. A cattle market, corn mill and hotel were soon built near the station, (courtesy of Mary Howse)

# Section 9

# Rye at War

In addition to the burden of casualties and cost imposed on the country in times of war, Rye's geographical location has placed it on the front line in the defence of the coast. The Royal Military Canal has been mentioned earlier in relation to the legacy of roads in the area. In addition, the Napoleonic War period saw the construction of a chain of Martello towers on the coast. Volunteers were formed following the 1859 French scare and formed part of local social life. In both world wars the district suffered civilian losses from air raids in addition to casualties among servicemen.

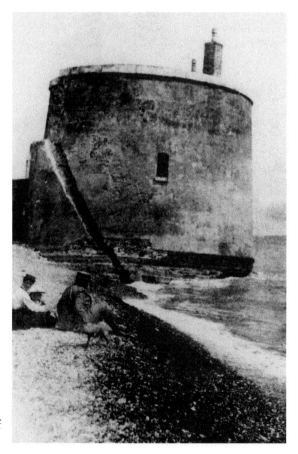

**Martello Tower No. 31, Late Nineteenth Century**
One of a chain of Martello towers constructed in brick in the Napoleonic War period, this site is now below high watermark off Dogs Hill Road, Winchelsea beach. It was gradually undermined by the sea along with several other towers between Winchelsea Beach and Cliff End, Pett. Three of the towers locally were blown up in gun-cotton experiments in the 1870s at a time when other towers were still inhabited, sometimes by coastguards. Each tower contained a basement magazine and store, upper-ground-floor soldiers' quarters and a gun platform at the roof level. Today, two towers remain – one at Rye, one at Rye Harbour, neither in use, (courtesy of Winchelsea Corporation).

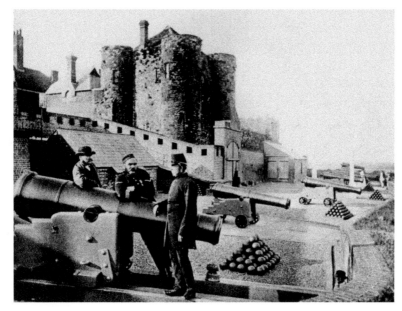

**Volunteer Artillery at the Gun Garden, Rye, Early 1870s**

Formed as an offshoot of the rifle volunteers in 1861, the 4th Cinque Ports (Hastings and Rye) Volunteer Artillery held annual prize firings at the Rye Battery until 1873. The Battery was otherwise in the charge of a Master Gunner of the Royal Artillery Coast Brigade. The soup kitchen attached to the Ypres Tower was built in 1870. The corps was disbanded in 1876 for insubordination having refused to march home from a match at Hastings taking the train instead, (courtesy of Rye Museum, Band Collection).

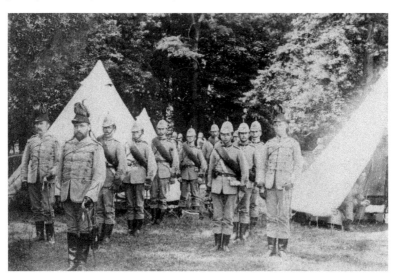

**Rifle Volunteers at Leasam Camp, Rye Foreign, 1889**

Rye 'E' Company of the First Cinque Port's Battalion Volunteer Rifle Corps was founded in 1885. In 1889 the annual camp of the battalion was held at the home of the officer commanding, Rye MP, Lt-Col. Arthur Montague Brookfield. Pictured is a stretcher bearer company. The officers (in plumed hats) were from left to right: Surg Capt. Marshall, Surg Major Julius Skinner, and Surg Lt E. W. Skinner, (courtesy of Rye Museum).

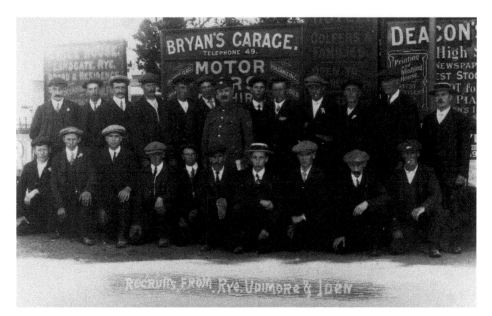

**First World War Recruits from Rye, Udimore and Iden**

A group of First World War recruits gathered at the station approach, Rye, with their recruiting sergeant. A large number of local recruits joined the Royal Sussex Regiment. One wonders how many of these faces did not return. The advertisements are of interest, two offering accommodation for golfers.

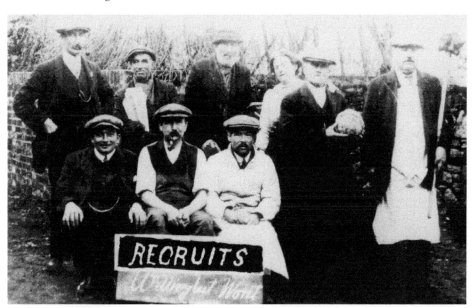

**'Recruits Willing But Won't' at Winchelsea, _c._ 1915**

Standing, from left to right: (not known), Barden, an ostler (with newspaper); (?) Field; Mrs Homard, landlady of the Old Castle Inn; George Gaywood, with cabbage, and Ernest Freeman, a plumber (with mop). Seated left to right: Dickie Homard, a baker; Jack Gallop, a builder; and 'Smiler' a painter. It seems likely that the men were willing to serve but were rejected on the grounds of their obvious age, (courtesy of Winchelsea Corporation).

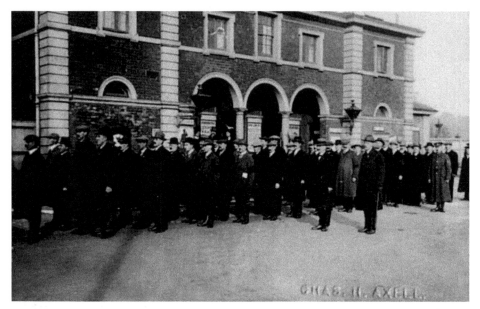

**First World War General Reserve Outside Rye Railway Station**
Equivalent to the Second World War's Home Guard, the group is here seen apparently on its way to a rally. One participant wrote to his uncle: 'I was so sorry you were not with us in the photo ... we mustered altogether between 700 and 800 ... we were the only Corps not in uniform,' (courtesy of Peter Ewart).

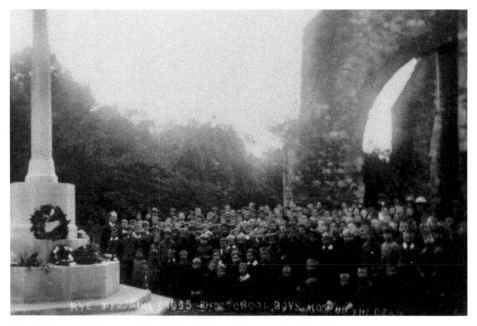

**'Rye Memorial Cross – Rye School Boys Honour the Dead'**
On Monday 20 October 1919, the day after the official unveiling, W. Sprigg Walker, headmaster of the Rye Boys Council School, led his pupils to the War Memorial, where he urged them to 'treat the memorial as a sacred emblem, not to play about it or deface it, but to salute it whenever you pass it', (courtesy of Rye Library).

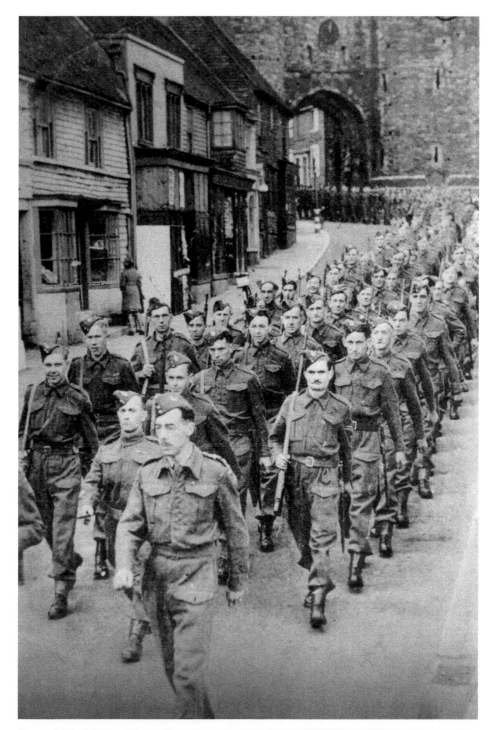

**Second World War Home Guard**
The Rye Company of the Home Guard, seen here marching down the Landgate, was divided into
five platoons, No. 1 (sixty strong in 1940) being responsible for the town. Note the girl on the
pavement, oblivious to the by then familiar spectacle of marching men, (courtesy of Rye Library).

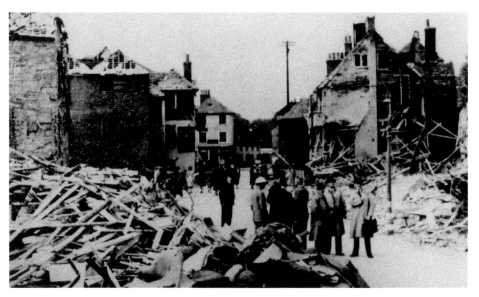

**Bomb Damage at the Strand, Rye**
Most of the buildings on one side of the street were destroyed in a hit-and-run raid by four German fighter-bombers on 22 September 1942. The cinema received a direct hit, killing the assistant manager, and the Methodist chapel was badly damaged. Elsewhere in the town gap sites still testify to the effect of bombing, (courtesy of Frank Palmer).

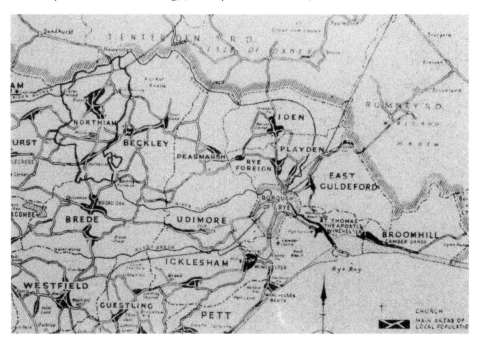

**Extract From a Map of Battle Rural District,** *c.* **1950**
Part of a map showing the area of the former Rye District Rural Council. Various amendments to the historic parishes had taken place, including the abolition of detached portions. Others were to follow, in particular the merging of Broomhill and the relic of old Winchelsea into the single parish of Camber, (courtesy of Northiam WI).